EX LIBRIS

NAME

Learn to Draw Like the Masters

VAMPIRES

COLLECTED MANUSCRIPTS DETAILING THE MASTERS' SECRETS
FOR STUDYING, DRAWING, AND PAINTING VAMPIRES

BY EUGENE CAINE

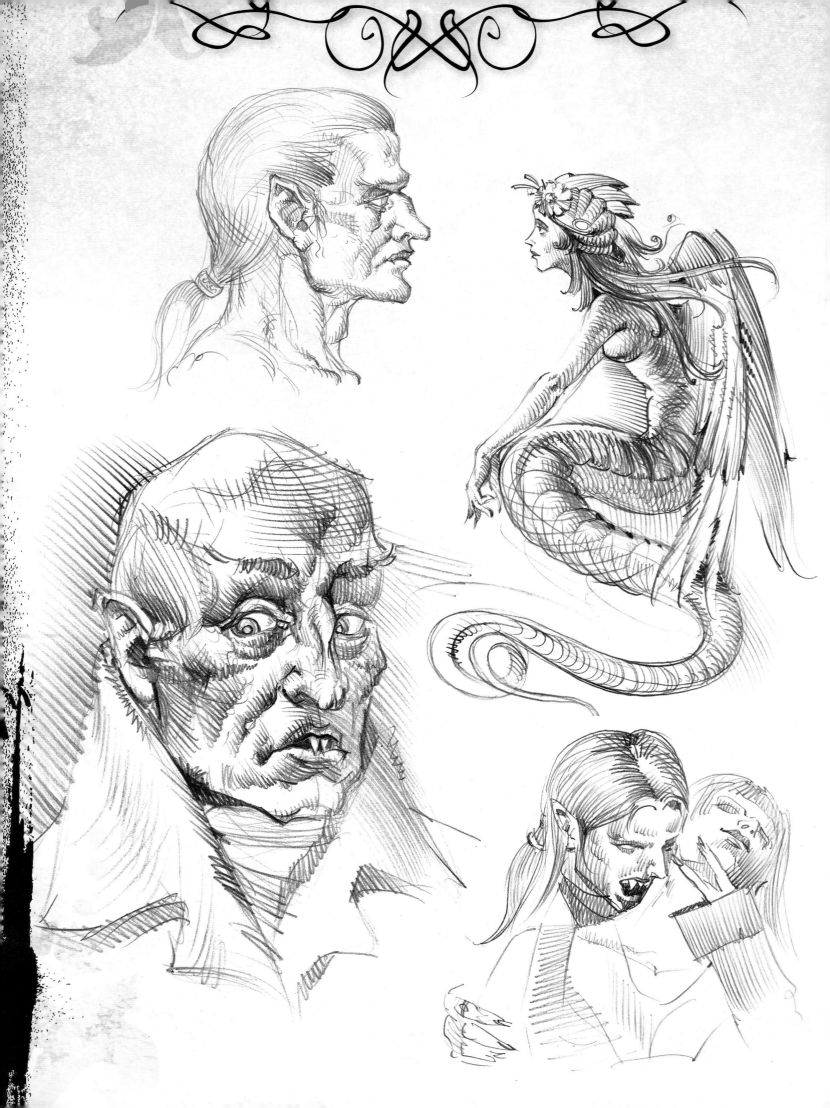

TABLE OF CONTENTS

Letter to the Reader . 4
Meeting the Masters . 5

VAMPIRE BASICS
The Study of Vampires . 6
Vampires Around the World . 8
A Guide to Observing Vampires . 10

RENDERING VAMPIRES
Pencil Techniques. 12
Building on the Basics. 14
Basic Anatomy and Perspective . 16
Color Theory and Palettes . 24

LEARNING FROM THE MASTERS

Rembrandt Harmenszoon van Rijn
Studying Rembrandt's Style . 26
Rembrandt Materials. 28
Working with Oils. 30
Representing a Vampire . 32
Building the Painting. 36

Michelangelo Buonarroti
Studying Michelangelo's Style . 42
Preparing a Textured Paper. 44
Establishing the Figure . 50
Controlling the Line. 52

Georges-Pierre Seurat
Studying Seurat's Style. 60
Representing a Vampire . 62

Vincent van Gogh
Studying van Gogh's Style . 78
Preliminary Sketchings. 80
The Power of Suggestion . 82

Oath of the Masters . 96

Dear Good Reader,

Twenty years ago while unearthing a collection of my grandfather's manuscripts from deep in the basement of his castle, I discovered a guide detailing the artistic secrets of the great masters. They changed my life and lives of everyone I love. Here I share them with you. As many pages of the original manuscript were damaged, I have tried to reconstruct the precious instruction they contained to the best of my ability, drawing on the creative wisdom passed down to me through my father and grandfather.

Furthermore, amidst the manuscripts lay an even more unexpected discovery—notes and records suggesting that some of the great masters had lived among, and perhaps even portrayed, vampires. We all have been exposed to vampire stories, lore and what I had always assumed to be mythology. But with this newly discovered material, I became inspired to search for real answers, seeking out these elusive beasts so much has been speculated about. Good reader, I discovered that they do indeed exist.

After traveling the world and furtively observing a variety of species, I now want to share the secrets I collected about the world of vampires, so that they pass on to the next generation the way my grandfather's secrets were shared with me. These vampires, frightening as they may seem, are also a treasure of the natural world, a rewarding subject to study both due to their amazing powers and fascinating customs.

I could fill a hundred books with details about these magnificent creatures of the night, but this guide will serve as a start, providing enough information to you so that you can embark on your own quest to learn about and record the "life" and experiences of the vampires who walk amongst us.

Observe your subjects with care, and be safe as you begin your own adventure. There is danger ahead—but the reward is much greater than the risk!

Eugene Caine

MEETING THE MASTERS

Who are these master artists whose secrets will illuminate even the darkest of nights? Theirs are the names that echo through history—Rembrandt Harmenszoon van Rijn, Michelangelo Buonarroti, Georges-Pierre Seurat, and Vincent van Gogh.

With his dramatic contrast of lightness and dark, Rembrandt was a master at creating high tension in his paintings. As you study how Rembrandt applied his aptitude for drama to portraits of wealthy patrons and the dead alike, you'll quickly surmise how his rich style is well suited for exploring the world of the aristocratic undead.

For ultra-realistic vampire portraits, we turn to the mastery of Michelangelo, who studied his subjects in depth and made copious notes and sketches before beginning a final work. Michelangelo was a man of science as much as he was an artist, developing an unrivaled familiarity with the human form and function. His timeless research remains a valuable resource for modern artists.

Vampires are masters of deception, appearing as one thing on first impression, and something else entirely upon a closer look. Seurat's works were equally complex— uncomplicated at first glance, but layered with complex detail when studied. Seurat's seriousness—and his preference for isolation—would've made him very empathetic toward the often-misunderstood creatures of the night that we'll be depicting in his unmistakable style.

Perhaps no other master understood dark urges and moody bouts the way van Gogh did. His insight into the psychological depths of the vampire would've been legendary, were he alive today to share them. Instead, though, we can learn from his emotional paintings, with their strength and energy befitting the powerful beast we study.

Within these pages, we'll explore the secrets held in the work of these four masters—both the nuances of their artistic methods and emotional insights that will help us get inside the vampire psyche. But first, you'll learn about the history of vampires, the many forms they take, and practical guidelines for studying these elusive creatures. We'll also explore basic art principles, including anatomy and color techniques, which will help us more accurately depict the various species we may encounter in our travels. Finally, we'll delve into the styles of the masters, developing spell-binding portraits step by step.

Michelangelo

Rembrandt

Seurat

Van Gogh

THE STUDY OF VAMPIRES

Vampires are highly intelligent and incredibly elusive. As such, many would argue that these fascinating creatures are merely myths—but I assure you, they are as real as you are. To appreciate the modern vampire, we must first look at its origins and history, enabling us to better understand the being as it exists today.

HISTORY OF THE VAMPIRE

Vampires have walked among us since the very beginning of time. Indeed, they co-existed with mortals in the very cradle of civilization, Babylonia—that is, if myths about Lilith are to be believed. She was well renowned for her penchant for drinking the blood of babies. But she wasn't the only vampire in those early days. Researchers uncovered an artifact from ancient Persia depicting a man in combat with a blood-sucking creature, for example. Nor were other ancient civilizations immune from the infiltration of these beings—from China and India to the Americas and beyond, legends of the living dead pervade the annals of history from the earliest days.

The vampire as we most often observe it today, however, originated in the old countries of Europe. Pagans took part in ceremonies where they dined on human flesh and drank human blood, perhaps thanks to a misunderstanding of the Christians' Holy Communion and its redemptive properties, perhaps due to some more sinister desire. They were not alone in their thirst for blood, which witches and doctors alike prescribed as a cure for any variety of illnesses in earlier centuries. But the vampire populations (and thus the myths surrounding them) swelled most in the fourteenth century; reported encounters with the undead reached epic proportions at about the same time as the plague spread—perhaps no coincidence, as the infection itself was credited to these night-dwelling entities. With some regularity during this period, blood-covered vampires were discovered outside their graves, which they'd obviously clawed their way out of. The negative reactions and fear that rose as a result of said encounters drove vampires underground for centuries—that is, until the nineteenth century, when Vlad "The Impaler" Dracula rose to prominence and became the most famous vampire of all.

Vampirism has never vanished, although the spread of rational and scientific beliefs has caused many to tut-tut the notion that these creatures exist. Vampires don't at all mind such doubts in the minds of the population, however, as it aids them, allowing them to hide in plain sight among us and escape detection.

VAMPIRE HUNTERS

There are two kinds of vampire hunters: the ones who seeks to prey on the predators, and the ones who simply wishes to observe and understand this enduring species. We fall in the latter category, of course, but because these creatures are extremely clever and dangerous, we also have made it a priority to understand the methods of the other kind of hunters, so that we might protect our own persons.

The bloodsuckers are strong and powerful, but they are not without weaknesses. That being said, it's important to distinguish fact from legend when it comes to vampire defense. For example, exposing a vampire to sunlight is actually ineffective with most species (although there are viral strains that make some vampires allergic to sun). And although a wooden stake is indeed effective, it works best if the stake is made from holly. See the information at right for a more detailed account of preparations you, too, should take before observing these fascinating creatures of the night.

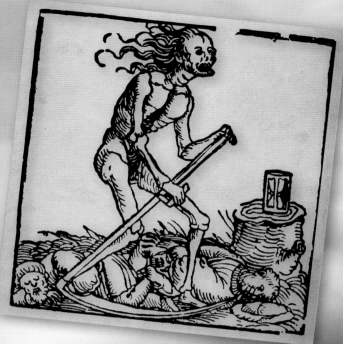

Defense Against Vampires

It's long been understood that garlic will ward off a vampire—and this lore turns out to be true. Wear a wreath of garlic around your neck night and day to protect yourself. Another simple passive defense is rice. Some vampires—at least those "living" in Asia—are unable to pass a pile of rice without first counting all the grains. The delay could save your life. Unfortunately, holy water and crosses won't keep vampires at bay, and the other defenses available to you are aggressive means. Those who wish to become vampire researchers should understand that, in some circumstances, they may be called upon to become vampire hunters, as well. In as such, it's important to come prepared with defenses against these powerful creatures, including silver blades and/or bullets and wooden stakes. A word of caution: These devices could be life-saving for you, but will ultimately destroy that which you seek to study.

VAMPIRES AROUND THE WORLD

Vampires appear in many forms, but some adaptation of these resilient creatures exist in every culture. Although we know a little about their appearance and feeding habits, observers should beware that there is no known way to extinct many of the species. Be a cautious observer, or you could easily transform from hunter to prey. Here are just a few of the vampire types we've personally encountered in our travels.

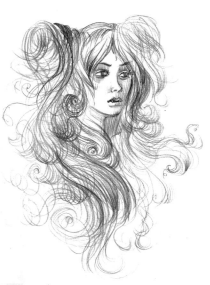

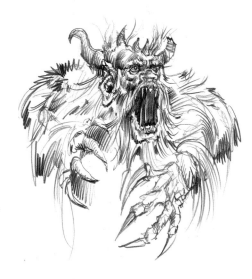

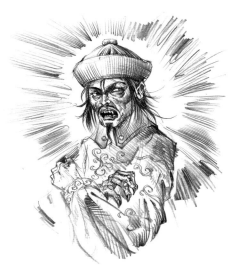

Scottish Vampire: *Baobhan Sith*
Physical form: *fairylike demon with appearance of a young woman with golden curls clad in a green dress. (Deer hooves are kept hidden beneath her dress.)*
Feeding habit: *attacks in the forest or wild, luring lone men into dancing before feeding on the blood and flesh.*

Russian Vampire: *Upyr*
Physical form: *dirty, blood-encrusted, animal-like ghoul.*
Feeding habit: *blood-drinking and devouring human prey after tearing it to shreds.*

Chinese Vampire: *Ch'iang Shih*
Physical form: *human, same as in life but bearing the wounds of death and displaying a greenish-white color to the flesh; immaterial form is a sphere of light.*
Feeding habit: *kills with poison breath before draining blood of humans.*

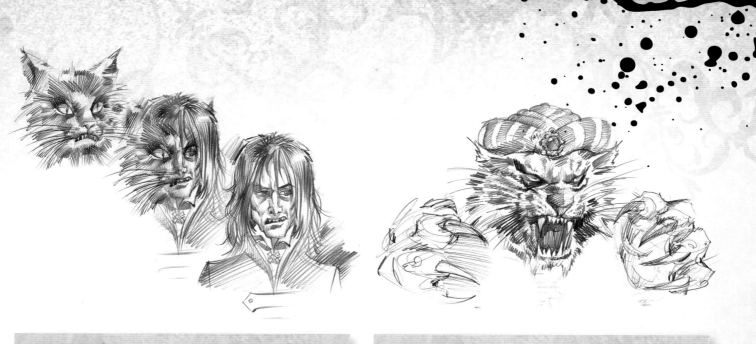

Japanese Vampire: *Nekomata*
Physical form: *shape-shifter, from human to feline; in vampire cat form, possesses two tails and can change size from domestic cat to larger than a human.*
Feeding habit: *sucks on human blood.*

Indian Vampire: *Rakshasa*
Physical form: *human with tiger facial features and claws or the reverse (tiger form with human features); bright yellow, green, and blue coloring.*
Feeding habit: *preys on flesh and blood of human victims.*

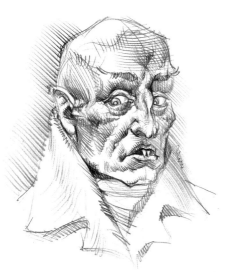

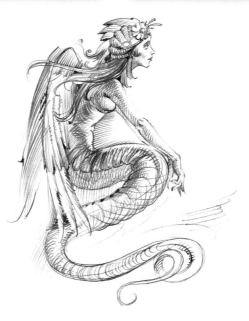

Romanian Vampire: *Nosferatu*
Physical form: *aristocratic male with long sharp teeth, pale (nearly translucent) skin, and superhuman strength.*
Feeding habit: *feeds on the blood of humans, extracted through the neck, at night only.*

Greek Vampire: *Lamia*
Physical form: *beautiful, winged female, with human features above the waist and serpent shape below.*
Feeding habit: *prefers the blood of handsome young men.*

Mexican Vampire: *Civateteo*
Physical form: *typical young Mexican mother, but with a pale face, resulting from her death in childbirth.*
Feeding habit: *preys on babies and children.*

A Guide to Observing Vampires

Before you set down the books and start off on your first vampire search expedition, you need to understand a few basics about where you'll find vampires, what you'll need to carry with you on your travels, and how to best record your findings.

IN SEARCH OF VAMPIRES

Although the earliest recorded vampires arguably lurked in Russia and parts of Eastern Europe, populations of vampires were living in Rome and Greece at the advent of civilization. Much like a virus, the species spread quickly, concurrent with myriad genetic mutations. Subspecies variations now exist in every part of the populated world. The trouble is that they roam only at night, and do their best not to call attention to themselves or their exploits. I recommend lurking about abandoned cemeteries and castles in old Europe to begin your quest. If you can't spot vampires there, you'll have little luck in less obvious habitats.

ESSENTIAL SUPPLIES

No traveler should be without basic hiking and backpacking supplies, including clothing appropriate to the weather condition, plenty of water, a sturdy pair of shoes, an extra pair of socks, plenty of water and food, maps and compasses, and of course, first aid. To record your observations, I recommend an artist's sketchbook and pencils. A flashlight or candles will do for lighting in dark conditions—but be sure not to draw too much attention to yourself! A camping knife will come in handy—in particular if it's made of silver—and I recommend a wooden stake and some garlic, just in case. (Holy water and a cross would be easy enough to pack; unfortunately, these items really do nothing to deter vampires. I'm sorry to say that's purely myth.)

EFFECTIVE FIELD NOTES

As this manuscript primarily focuses on the methods of the masters and the way you can apply their art techniques to your vampire portraits, I'd like to take a moment to discuss the text portion of your field notes. Your written recordings should carry the same authority as your drawings, noting every detail as soon as possible after an encounter. Now, when you're out of breath from running and your heart is practically pounding out of your chest after seeing a bat eye to eye, it can be difficult to form coherent thoughts. Simply jot down your immediate reaction and make rough sketches in the moment, and then return later to refine your drawing and clarify your terrified thoughts. Those who you share your notes with afterward will appreciate the care you take in documenting your vampire studies.

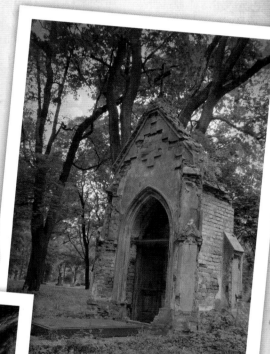

PENCIL TECHNIQUES

From their physical form to their manner of dress and manor of abode or other surroundings, vampires offer the artist an array of textures to re-create. Before you begin your portraiture, it's helpful to familiarize yourself with your art tools and their capabilities, in particular the versatile pencil. Learn how to grip your pencil and control your strokes to achieve a variety of tones and textures by experimenting with different grades of pencils and types of lines.

When you've warmed up, it's time to practice drawing what you see, starting with simple objects. Squint your eyes, paying attention to the *value* (the relative darkness or lightness of a color or of black) of the *highlights* (where light strikes an object) and shadows of your subject. Shading your drawing according to these value differences will create the illusion of depth and three-dimensional form. Keep practicing, and soon you'll be ready to approach a much more complex subject—the ever-elusive vampire.

HOLDING THE PENCIL

Some artists prefer an underhand grip (above right), which is a great way to create even, solid shading and soft blending. The overhand grip (right) can provide more mechanical control, so it's typically reserved for firm, precise strokes.

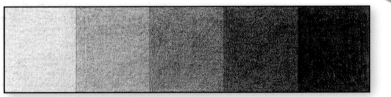

VALUE SCALE

Making your own value scale, such as the one shown above, will help familiarize you with the different variations in value. Work from light to dark, adding more and more tone for successively darker values. Different pencils produce varying value ranges; this scale was drawn with a standard HB pencil.

BASIC DRAWING TOOLS

Each of the master artists' tools are detailed in the following projects, but you should keep a variety of pencils and pens on hand. I recommend trying different sketching, graphite, charcoal, mechanical, and white pencils. You may also want to use a pen for inking your finished drawings.

HATCHING

The most basic method of shading is to fill an area with hatching, or a series of parallel pencil strokes created using an even, back-and-forth motion.

PRACTICING VARIED STROKES

Parallel strokes are a common way of shading drawings—by varying the grip of your pencil, the length of your strokes, and the spacing between lines, you can create a range of effects, even dynamic movement. Whether making scribbles or bold, wide strokes, let your whole arm get into the action. Relax—if you make a mistake, you can always correct it later.

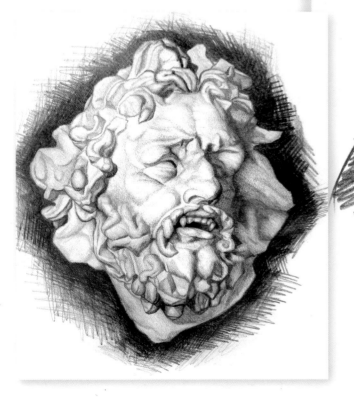

CREATING VOLUME

This "sculpted" vampire is a great example of the way that you can make values work for you. Note the full range of values, from the white of the paper to such a dark gray that it's almost black. It's the variations in the shading that give the sculpture its three-dimensional effect.

13

BUILDING ON THE BASICS

Now that your arm and hand are warmed up, let's practice on an actual vampire—drawing, that is. But before we can apply the shading techniques you've been rehearsing, we'll need to create an outline. I recommend starting out by breaking down the subject into a few basic shapes: circles, squares, rectangles, triangles, and the like. When these shapes are properly shaded (using the range of values we discussed earlier to create highlights and shading), they develop into forms—or three-dimensional versions of the shapes, such as spheres, cubes, cylinders, and pyramids. That's the first step to any drawing: sketching the shapes and using shading to develop them into forms.

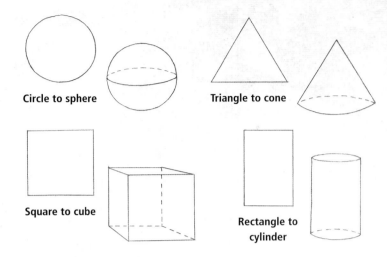

Circle to sphere

Triangle to cone

Square to cube

Rectangle to cylinder

TRANSFORMING SHAPES INTO FORMS

Here I've drawn the four basic shapes and their respective forms. I think of the shapes as flat frontal views of the forms; when tipped, they appear as three-dimensional forms. Use ellipses to show the backs of the circle, cylinder, and cone; draw a cube by connecting two squares with parallel lines.

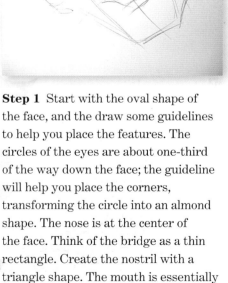

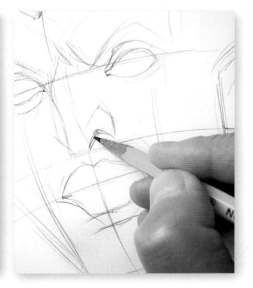

Step 1 Start with the oval shape of the face, and the draw some guidelines to help you place the features. The circles of the eyes are about one-third of the way down the face; the guideline will help you place the corners, transforming the circle into an almond shape. The nose is at the center of the face. Think of the bridge as a thin rectangle. Create the nostril with a triangle shape. The mouth is essentially a square, but with corners and the bow of the top lip altering the central shape.

Step 2 The underhand stroke is ideal for loose strokes. Although you want the widow's peak to be defined, using a grip like you would for handwriting would create a too precise stroke, producing a hard edge not at all representative of the vampire's hairline. A grip with more control, however, would be perfect for a hard surface, like the enamel of a vampire's teeth.

Step 3 As I go back over my lines to refine my drawing, I'm constantly switching grips and the firmness of my stroke depending on the depth of the value I'm trying to create. The inner nostril is one of the darkest values on the face, so I can use pretty heavy, short lines in this area to produce the dark value I need to create.

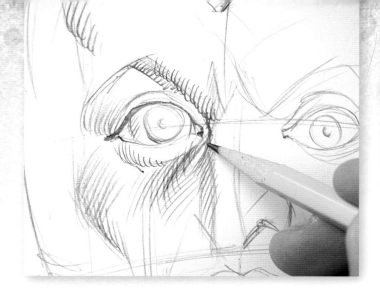

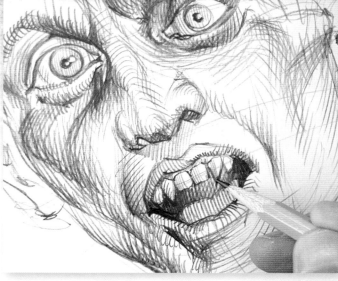

Step 4 Hatching and cross-hatching produce a different kind of shading. Depending on how close you place the strokes, you can create great variation in value. Do you see how I make the strokes much tighter in the deep shadow at the corner of the vampire's eye, whereas the strokes gradually become wider with less overlap as we move away from this defined area of shadow?

Step 5 Here we are using the overhand grip to create the precise line and defined edge of the very sharp tooth of our vampire subject. As I noted in step 2, when we were creating the vampire's hairline, the grip of the pencil and the pressure of your stroke will both affect the kind of line and texture you produce. Note the curvature on many of the lines making up the lighter shading of the face; the lines are loosely placed and curled, both techniques that help create the rounded appearance of the flesh.

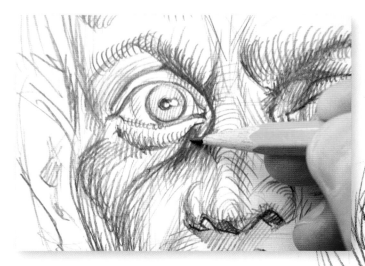

Step 6 The sharpness (or dullness) of your pencil tip will also affect your end product. This duller tip produces wide, smudgy strokes, perfect for areas of deep, dense shadow. In other areas, precise parallel lines indicate smooth surfaces (such as the glossy surfaces of the eyes and teeth). They also denote direction, as with the parallel lines on the vampire's tongue.

FINISHED PORTRAIT

When your drawing is complete, you will have used many different types of lines, from circular strokes and scribbles to curving lines and hatching. It's the combination of these techniques that help transform shapes into forms, and the combination of those forms combine to become a finished artwork with a three-dimensional look and feel.

15

BASIC ANATOMY AND PERSPECTIVE

Shading isn't the only method artists use to create the look of three dimensions on a two-dimensional paper or canvas. If you follow the rules of perspective, it will help you create drawings that inhabit a three-dimensional space with depth and distance. In addition to adding a sense of realism to a work, perspective helps keep all the objects on a picture plane in proper proportion.

I'll cover some of the specifics here—and while I'm at it, I'll also take the opportunity to teach you to observe vampires from every angle, even from the inside out, to get a better understanding of their form and what it is you're seeing. A familiarity with the details will help, but you don't have to memorize everything you read here—just keep in mind that the most important thing about perspective is that objects closer to the viewer are larger than objects that are father away.

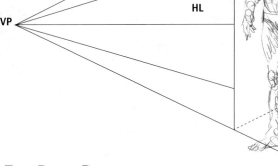

TWO-POINT PERSPECTIVE

In two-point perspective, there are two vanishing points (VPs). A three-dimensional cube best demonstrates this concept. First draw a horizon line (HL), and place one VP at the far left and another VP at the far right. VPs are always on the HL at the viewer's eye level. Draw a 90-degree center "post" that extends above and below the HL at an equal distance. Draw lines from the top and bottom of the post that extend to each VP. Add two more vertical lines to the left and right of the center post to represent the corners of your cube. At the point where each corner post intersects the VP lines, draw a new line back to the opposite VP. These lines form the back edges of your cube, and the place where they intersect is the back corner post. The perspective of the VPs affect the position of the vampire within the cube above.

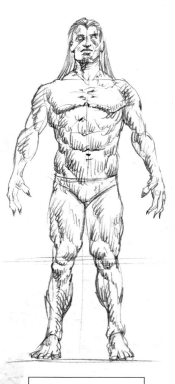

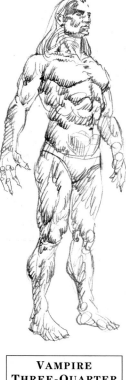

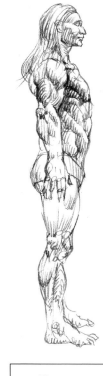

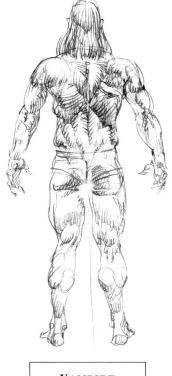

VAMPIRE FRONT VIEW

VAMPIRE THREE-QUARTER VIEW

VAMPIRE SIDE VIEW

VAMPIRE BACK VIEW

FORESHORTENING

Viewpoint can distort a vampire's features beyond their usual exaggeration. When we view a face straight on or in profile, the features are very symmetrical and proportionate. But when we switch to a three-quarter view, features like the eyes and lips must curve with the face as it turns. And when we switch to a more extreme angle, suddenly the way we see the features can change dramatically thanks to an effect called "foreshortening." In foreshortening, an object is at an angle to the picture plane that makes it look distorter, shortening the lines closest to the viewer. So, for instance, if a hand is thrust toward your face, the lines of the arm are foreshortened from your perspective. The best way to handle these situations is to draw what you see, not what you expect to see.

FRONT VIEW FROM BELOW

Even with the head facing forward and features symmetrical, a tilted head makes the chin appear more prominent, whereas the forehead recedes. The length of the face is foreshortened.

THREE-QUARTER VIEW FROM ABOVE

A head viewed from above appears to have a much larger forehead, and the shape of the brow and nose are very different from before. Once again, the length of the face is affected by foreshortening.

17

SKELETAL STRUCTURE

While most species of vampires are very similar to humans in their anatomical structure, there are differences between the two, so a close study is recommended. A working knowledge of anatomy is essential for any artist who wishes to render the most realistic form possible—after all, it's the structure underneath that affects the form we see.

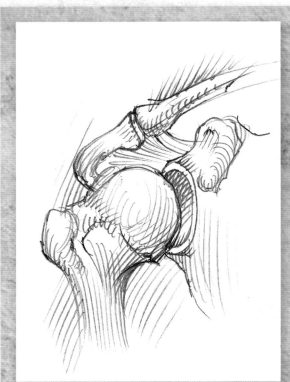

REVEALING STUDY

Seeing what's underneath can be very revealing—for example, the way the shoulder is positioned in the socket shows us both the scope and the limitation of the rotation, something it's difficult to assess when the skin is covering the joint.

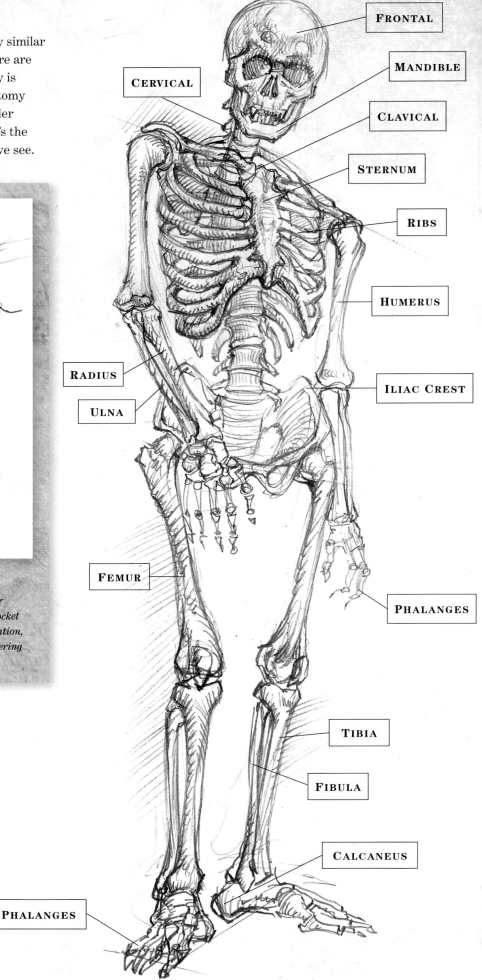

FRONTAL

MANDIBLE

CERVICAL

CLAVICAL

STERNUM

RIBS

HUMERUS

RADIUS

ULNA

ILIAC CREST

FEMUR

PHALANGES

TIBIA

FIBULA

CALCANEUS

PHALANGES

18

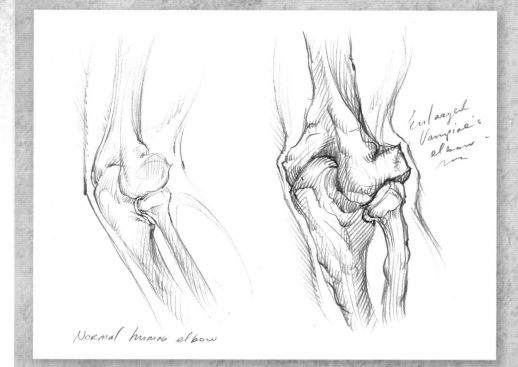

Normal human elbow

Enlarged vampire's elbow

VAMPIRE DISTINCTIONS

If you were to compare the skeleton of a normal human to that of a vampire, you would notice some very interesting differences. We know that vampires are very strong—that strength starts below the muscles, at the bone level. The vampire's bones are thick and hardy, almost like an old tree. The joints are a bit less smooth in appearance, but work just as well, providing the night-dweller with incredible speed and power.

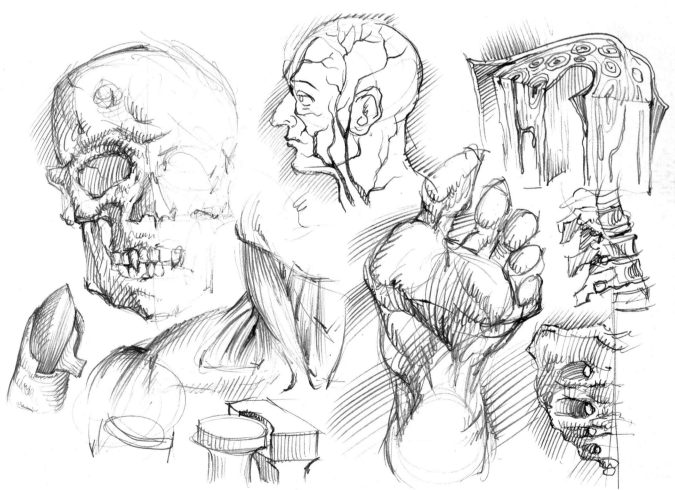

PRACTICE SKETCHES

In your research, it's possible you may come across a slain vampire's bones. There's no better opportunity to study the creature's structure. If you should be so lucky, make as many reference sketches as possible so that you can rely on them for accuracy in your future artworks. Even if you are not fortunate enough to discover a vampire's final resting place, making quick sketches of a vampire's skull or other body parts is good practice—and given the slightly macabre subject matter, these sketches are even more important, because they could potentially become elements in your portraits, as well.

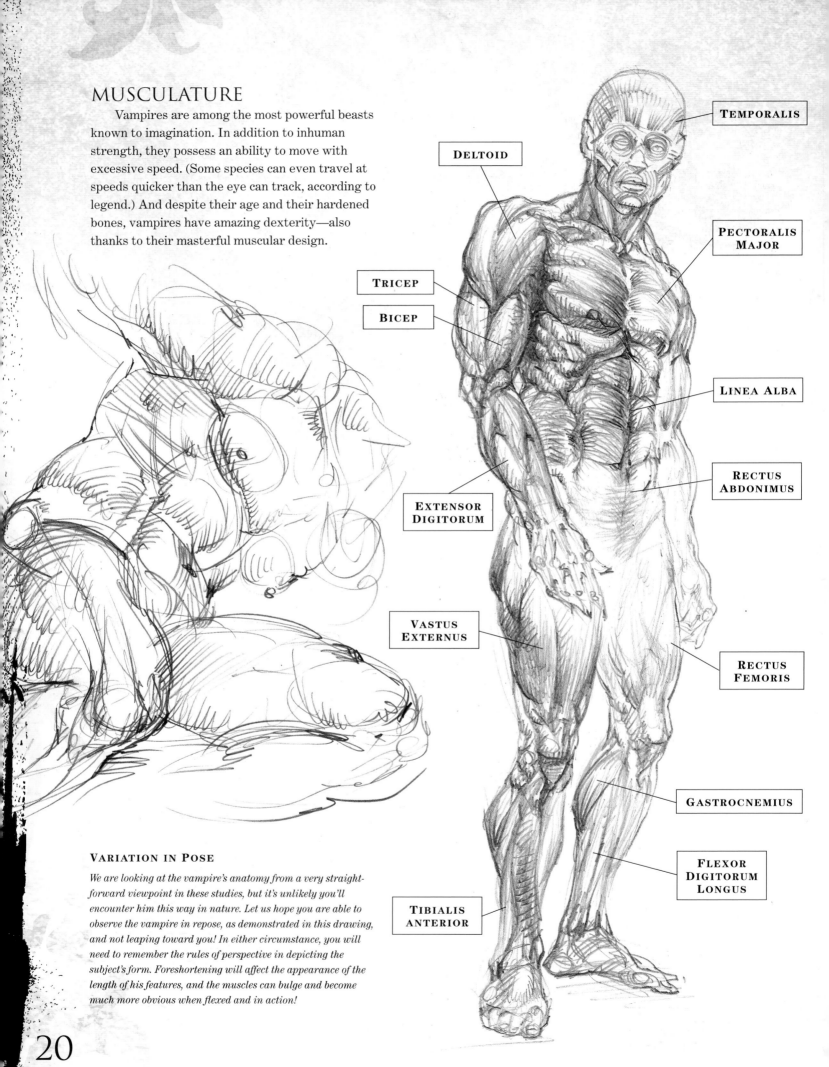

MUSCULATURE

Vampires are among the most powerful beasts known to imagination. In addition to inhuman strength, they possess an ability to move with excessive speed. (Some species can even travel at speeds quicker than the eye can track, according to legend.) And despite their age and their hardened bones, vampires have amazing dexterity—also thanks to their masterful muscular design.

TEMPORALIS

DELTOID

PECTORALIS MAJOR

TRICEP

BICEP

LINEA ALBA

RECTUS ABDONIMUS

EXTENSOR DIGITORUM

VASTUS EXTERNUS

RECTUS FEMORIS

GASTROCNEMIUS

FLEXOR DIGITORUM LONGUS

TIBIALIS ANTERIOR

VARIATION IN POSE

We are looking at the vampire's anatomy from a very straight-forward viewpoint in these studies, but it's unlikely you'll encounter him this way in nature. Let us hope you are able to observe the vampire in repose, as demonstrated in this drawing, and not leaping toward you! In either circumstance, you will need to remember the rules of perspective in depicting the subject's form. Foreshortening will affect the appearance of the length of his features, and the muscles can bulge and become much more obvious when flexed and in action!

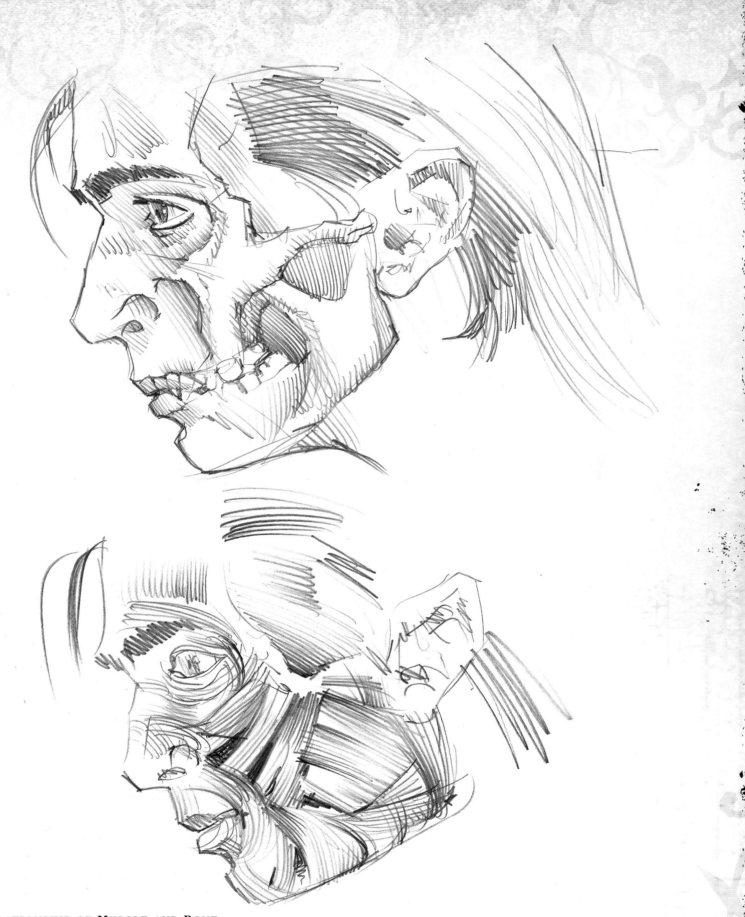

RELATIONSHIP OF MUSCLE AND BONE

The position and shape of the muscles is much easier to understand if you think about the way they relate to the bone underneath. The muscles aren't free-standing—they attach to the skeleton in ways that bind all the pieces together and give them maximum performance. When you're looking at the muscles, think about what's underneath—and also what's on the surface. For example, how do these muscles of the jaw operate, allowing our mouth to open and close to chew or talk . . . or bite . . . or scream!

21

PHYSICAL DETAILS

Vampires are much more than the sum of their various parts—but the better we understand each individual component of this complex being, the better we can understand it. Let's take a closer look at some of the features we may have missed.

THE FEMALE VAMPIRE

Up until now, we've been focusing on the male vampire. But we should not neglect the female, who makes many appearances in legend and lore. The essential shape and form is again humanlike, and the female of the species differs in ways similar to human women, in particular possessing a fuller chest, a wider pelvis and hips, and a more defined hip-to-waist ratio. Remember when you're portraying a female that the general shape and proportions of the physical form underneath affect the way clothing drapes on a subject—that's one reason many artists will "draw though," first drawing the figure underneath before adding the clothes to ensure greater accuracy.

THE SKIN EFFECT

As we already discussed, the bone and muscle are essential to the form of the vampire. But there are more layers to the vampire than just these. His swollen veins and dehydrated skin layer on top of these understructures to create a very different picture. Because of the tightness of the vampire's flesh, which has little fat or water, we can still see the bones distinctly—such as the enlarged joints of the wrist and knuckles and of the hand. The tendons are strained against the skin, as are the very evident veins. All these factors are important to observe if you wish to portray the vampire with accuracy.

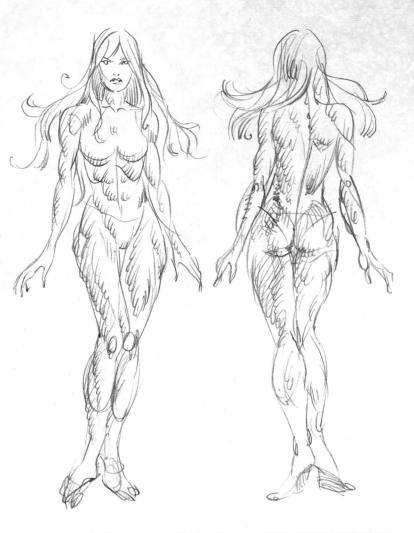

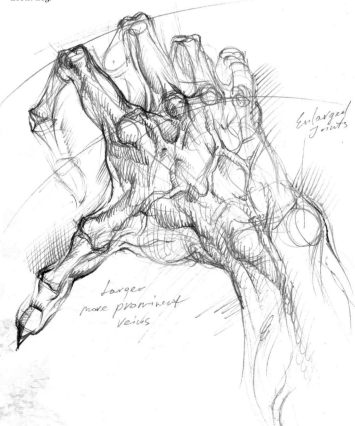

Enlarged joints

Larger more prominent veins

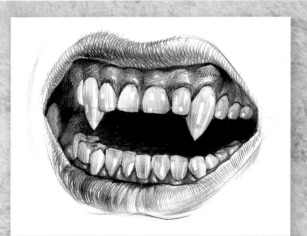

SHARP TEETH

In most species of vampires, the only particularly pointed teeth are the elongated canines. The fangs are razor sharp so that they can pierce not just the skin, but the particular vein or artery of the vampire's choice, without making a mess. Now, there are species of vampires that dine on flesh, not just blood, and it should be noted that their teeth are more animal-like and much sharper all around—but the set of choppers you see here are typical of the vampires you'll encounter with the most frequency.

Clothing Options

Vampires prefer clothing styles that cloak their identity, whether that means dressing in the fashion of the day to blend in a crowd or donning a hooded jacket that disguises their features until someone gets up close (by which time, it's too late—vampires can strike with inhuman speed). When choosing the dress for your portraits, the focus should be on the vampire's meticulous attention to detail. After all, vain beings like these don't dress in dirty sweatshirts and torn-up jeans.

DISGUISING

Hoods (or hats) that provide cover for the face and leave the vampire's features in shadow are popular among the night-dwelling set, for obvious reasons. The trick with these items is to shade the recesses of the face (and neck); after all, if all the facial features were visible and well lit, what would the point of the hood be?

DRAPING

Vampires enjoy fabrics that drape about them, both because it's difficult for them to keep warm with as little body fat as they have—and because flowing fabrics tend to be and look expensive, and vampires are very conscious of their social status. The drapes and folds appear in the fabric when you place the shadows (it's something artists call drawing the "negative space").

LINING

The inner lining of coats and cloaks are typically lined with a smooth fabric. These items are close to the body, and they aren't exposed to direct light. This shading is different from the shadows of the folds, as there's no variation—the shadow is solid and the fabric is smooth, so starting with light parallel strokes is ideal.

COMPLETE ENSEMBLE

We're not sure where our vampire is headed in this get-up, but he certainly looks comfortable. (Perhaps he's rented Let the Right One In for movie night at home?) Regardless of where he's wearing it, the finished look is thanks to a second layer of strokes that deepened our shadows in the folds, along with long smooth vertical strokes on the inside of the cloak to produce the impression of movement as his cape flips wide.

COLOR THEORY AND PALETTES

Knowing a little about color theory will help you mix colors and capture the diverse colors of vampires. All colors are derived from three *primary* colors—red, yellow, and blue. (The primaries can't be created by mixing other colors.) *Secondary* colors (orange, green, purple) are each a combination of two primaries, and *tertiary* colors (red-orange, red-purple, yellow-orange, yellow-green, blue-green, blue-purple) are the results of mixing a primary with a secondary. *Hue* refers to the color itself, such as red or green, and *intensity* means the strength of a color, from its pure state to one that is grayed or diluted. Varying the values of your colors allows you to create depth and form in your paintings. (See page 12 for more information on value.)

COLOR WHEEL

A color wheel (or pigment wheel) is a useful reference tool for understanding color relationships. Knowing where each color lies on the wheel makes it easy to understand how colors relate to and react with one another. Whether they're opposite one another or next to one another will determine how they react in a painting—which is an important part of evoking mood in your paintings. (See the following sections on color psychology and complements versus analogous colors.)

COLOR PSYCHOLOGY

Colors are referred to in terms of "temperature," but that doesn't mean actual heat. An easy way to understand color temperature is to think of the color wheel as divided into two halves: The colors on the red side are warm, while the colors on the blue side are cool. As such, colors with red or yellow in them appear warmer. For example, if a normally cool color (like green) has more yellow added to it, it will appear warmer; and if a warm color (like red) has a little more blue, it will seem cooler. Temperature also affects the feelings colors arouse: Warm colors generally convey energy and excitement, whereas cooler colors usually evoke peace and calm. This explains why bright reds and golds are used in royal settings and greens and blues are used in bathhouses and sitting rooms.

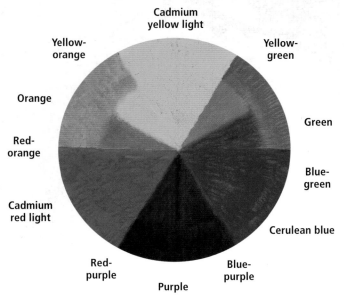

WARM COLOR WHEEL

The color wheel above shows a range of colors mixed from warm primaries. Here you can see that cadmium yellow light and cerulean blue have more red in them (and that cadmium red has more yellow) than their cool counterparts in the wheel below do.

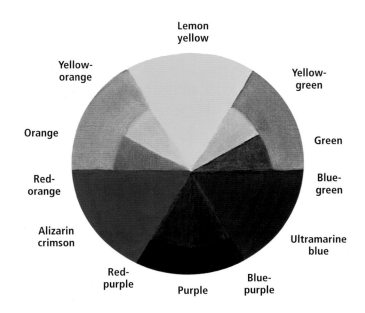

COOL COLOR WHEEL

This cool color wheel shows a range of cool versions of the primaries, as well as the cool secondaries and tertiaries that result when they are mixed.

COMPLEMENTARY AND ANALOGOUS COLORS

Complementary colors are any two colors directly across from each other on the color wheel (such as purple and yellow). When placed next to each another in a painting, complementary colors create lively, exciting contrasts, as you can see in the examples at right.

Analogous colors are those that are adjacent to one another (for example, yellow, yellow-orange, and orange). And because analogous colors are similar, they create a sense of unity or color harmony when used together in a painting.

COMPLEMENTARY COLORS

Here are three examples of complementary pairs. Using a complementary color in the background will cause your subject to seem to "pop" off the canvas. For example, place bright orange flames against a blue sky, or enliven a green dragon by placing it against a fiery red sunset.

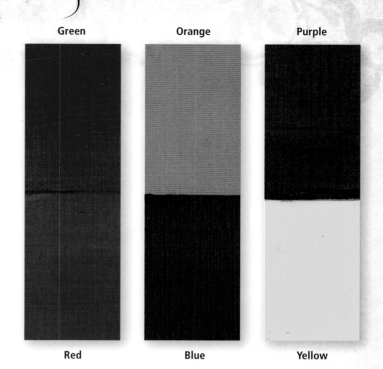

Green Orange Purple

Red Blue Yellow

COLOR PALETTES OF THE MASTERS

In addition to special drawing and painting techniques, you will discover the color secrets of the masters. Most of your artwork will be quick pencil or ink studies done in the field. However, creating a finished painting gives you a deeper glimpse in the vampire's mind. Here you'll find an overview of the distinct palettes of Rembrandt, Seurat, and van Gogh. You'll learn more about each master's style and use of color later, but that doesn't mean you can't begin experimenting with color combinations now!

SEURAT'S PALETTE

Seurat's color choices are light and airy pastels, seemingly a contrast to the vampire spirit. The greens and blues of nature are prominent.

REMBRANDT'S PALETTE

Rembrandt's colors are earthy, rich, and dark. Strong dark colors set the tone for his paintings, which rely predominantly on colors in the neutral family.

VAN GOGH'S PALETTE

Van Gogh prefers bold primary colors with emotional appeal, mixing golden yellows with bright blues, using vibrant greens and stark reds.

STUDYING REMBRANDT'S STYLE

Rembrandt Harmenszoon van Rijn (1606–1669) wasn't born into an artistic family or a wealthy one. The son of a Dutch miller, Rembrandt's upbringing was ordinary. Despite his family's limited finances, he was able to attend university. But the young Rembrandt was bored with school, so he instead turned to art.

He began studying under a local teacher, but soon became better than his instructor. So he moved to Amsterdam, where he again quickly mastered his lessons. At the age of 22, he began teaching others.

In this early period, Rembrandt's work focused on light and shade, and he took a real interest in lines and color, as well as in the people around him. He was influenced by a number of Italian artists, including Caravaggio. But he took what these Renaissance and post-Renaissance artists did and advanced it, creating his own signature style.

Self Portrait, 1629 (oil on canvas), Rembrandt Harmensz. van Rijn (1606–69) / Mauritshuis, The Hague, The Netherlands / The Bridgeman Art Library International.

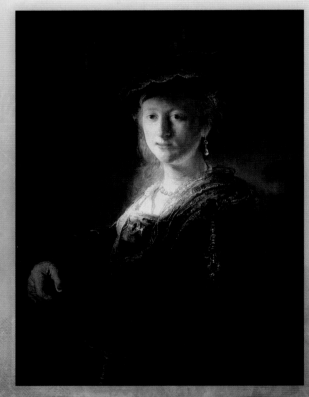

Young Woman in Fancy Dress (oil on canvas), Rembrandt Harmensz. van Rijn (1606–69) / Private Collection / The Bridgeman Art Library International.

LIGHT AND DARK

From early on, the Italians influenced Rembrandt, who adopted their style of chiaroscuro *(Italian for "light-dark"), using bold contrasts between light and dark to achieve volume and dimension. His colors ranged from deep black to bright white, which heightened the tension of the subject and composition—creating the kind of drama perfect for vampire portraits.*

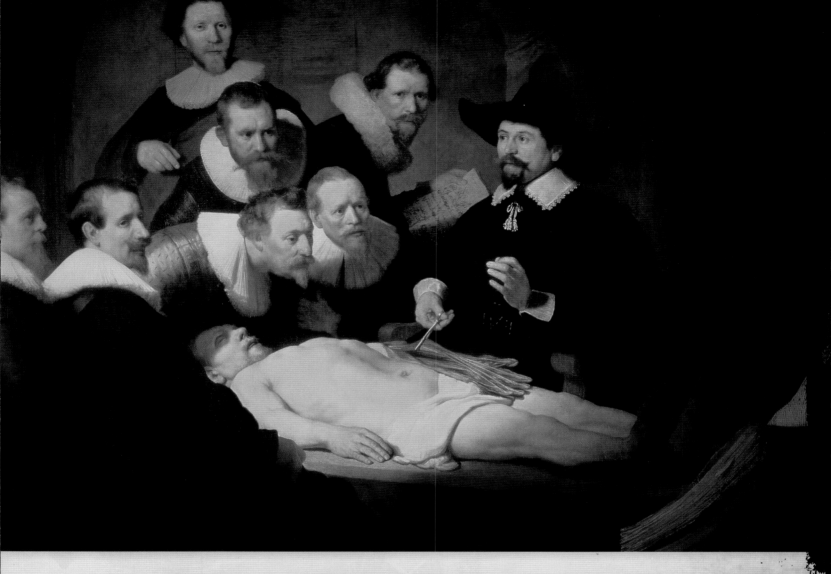

In Rembrandt's time, death wasn't an uncommon subject, and the skin tones of a corpse are not unlike vampire's. **The Anatomy Lesson of Dr. Nicolaes Tulp,** *1632 (oil on canvas), Rembrandt Harmensz. van Rijn (1606–69) / Mauritshuis, The Hague, The Netherlands / The Bridgeman Art Library International.*

Rembrandt's success permitted him to marry the daughter of an art dealer, Saskia van Uylenburgh, in 1634. Around this time, Rembrandt began accepting portrait jobs from wealthy patrons. He also frequently painted his wife, and later his young son, Titus. Those paintings were recognizable for their strong lighting effects.

But things fell apart after his wife's death. Rembrandt spent more money than he had coming in, and he was forced to auction off his own art collection to pay his debts. At that time, he shifted focus to creation of art for his own enjoyment, and these works are now considered some of his best. When he had no other model available, Rembrandt regularly painted or drew his own image.

In his lifetime, Rembrandt created more than 600 paintings and 1,500 drawings. Although there are no known vampire portraits among them, he did capture a number of aristocrats with his vibrant brushstrokes. And we all know vampires regularly hid among the aristocrats.

In his lifetime, Rembrandt created more than 600 paintings and 1,500 drawings.

REMBRANDT MATERIALS

The most common painting surface is canvas. In Rembrandt's day, artists had to stretch the canvas fabric and attach it to a wooden frame before they could begin painting, but in modern time canvases on wood frames are readily available at art supply stores. For practice work, small canvases of any quality are helpful, but you'll want to use a larger, 20" x 24", artist-grade canvas for your final vampire portrait. Before you being painting on the canvas, you'll need to take one more step of preparation, though—gathering the appropriate paints and brushes.

Rembrandt and other artists of his time period used oil paints for their work, building up layers of color on their canvases. Oil paints are a versatile medium that dries slowly, giving you a lot of time to smooth out brushstrokes and perfect your painting. For Rembrandt's style, you'll need a variety of brown paint hues to work with to build up the rich, dark tones of the chiaroscuro. And reds, yellows, and white will come in handy for the lighter end of the range.

Artemisia, 1634 (oil on canvas), Rembrandt Harmensz. van Rijn (1606-69) / Prado, Madrid, Spain / The Bridgeman Art Library International.

For Rembrandt's style, you'll need a variety of brown paint hues to work with to build up the rich, dark tones of the chiaroscuro.

PALETTE KNIFE

WOODEN PALETTE

LARGE
SABLE
BRUSH

You'll also find a palette knife useful for transferring paint from the tube to the palette; you can also use it to apply large amounts of paint to the canvas. (Because it is neither sharp nor silver, it won't, however, protect you from a vampire on the prowl.) When crafting with oil paints, I prefer to work from a thin, wooden palette, like the masters favored. I also keep a variety of brushes on hand, including several different sizes of round and flat brushes, as well as a fan-shaped brush. A large, wide brush like the sable brush pictured above will work well for blending the base layers or underpainting the canvas.

PRIMING YOUR CANVAS

Master artists cover their canvas with a non-absorbent material to prevent paint from soaking in too deeply. They typically prepare, or prime, their canvas with a gesso, which is a layer of thick, sticky white paint that seals the canvas. Rembrandt used a similar technique to that of the old masters in Holland or northern Europe, boiling fish to create a sort of glue, separating the glue from the bones, and mixing it with a white chalk, pigment and oil to create a homemade gesso. Luckily, you won't have to go fishing before you begin painting, as pre-prepared gesso is available at art stores these days. You simply need to apply two to three thin layers to the canvas, allowing the gesso to dry completely before you begin applying paint. In fact, if you want to skip this step entirely, you can even purchase a pre-primed canvas, although it will be a little more expensive.

WORKING WITH OILS

The masters used oils in many different ways, producing a variety of results and styles. It's good for any novice artist to have an understanding of some of the many techniques available to you with this versatile medium. Even Rembrandt got his start by mimicking the techniques of the painters who came before him. It was only over time that he developed his own method, which involved making smooth blended strokes that he achieved over many layers of paint. No matter the style of application, you'll want to begin your oil masterpiece with a base or *underpainting*.

Step 1 Begin by mixing a large quantity of the color you'll be using to tint the canvas. (Whatever color you apply as the base will peek through the later layers, setting the tone for your portrait.) Here, I've mixed yellow ochre, burnt sienna, and burnt umber for a rich brown color. Using a large brush, I apply a thin layer (or *glaze*) of oil paint mixed with oil medium. (There are many medium types; this one thinned the paint.) You don't have to be particularly careful with the base coat application; uneven patches will add interest and variation to the final painting.

Step 2 Once you have covered the canvas with paint, use a large flat brush to distribute the paint across the canvas with horizontal and then vertical strokes. Let this underpainting dry for 24 hours.

OIL TECHNIQUES OF THE MASTERS

The variety of effects you can achieve with oil is virtually limitless; it simply depends on your brush selections and application methods. A few of the masters' favorite ways to apply paint to the canvas are shown below, including blending and glazing. The more time you spend exploring and experimenting with the options available to you, the better painter you'll become.

PAINTING THICKLY

Load your knife with thick, opaque paint and apply it liberally to create texture.

DRYBRUSH

Load a brush, wipe off the excess paint, and lightly drag it over the surface to make textured strokes.

GLAZING

Apply a thin layer of transparent color over a dry color. Let dry before applying additional layers.

THIN PAINT

Dilute your color with a thinning medium and add soft, even strokes for transparent layers.

BLENDING

Use a clean, dry hake or fan brush to lightly stroke over wet colors, resulting in soft, gradual blends.

STIPPLING

Using the tip of a brush or knife, apply thick paint in irregular masses of small dots to build color.

REPRESENTING A VAMPIRE

Obviously, even though vampires "live" among us, it's going to be a little difficult to find one around to pose for your portrait. If you happen to know one—someone work with, perhaps, or someone in your neighborhood—invite him over for a cup of tea and ask him to pose. But if that proves too difficult, you can always just look at yourself in the mirror. Rembrandt did a lot of self portraits when another model wasn't available—this can be your own self portrait, only you'll transform yourself into a vampire.

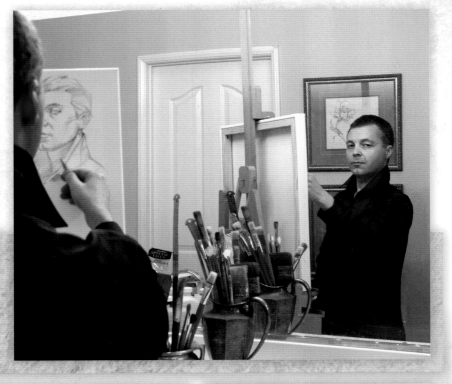

DRAWING A SELF PORTRAIT

For the drawing stage, you'll need a mirror of course, along with a good source of light (just one source is best, so you can create a solid dramatic shadow—the masters liked that a lot), an easel or a nice board to clip the paper to, a variety of good sharp pencils, and an eraser. You might even want some charcoals for shading later in the drawing.

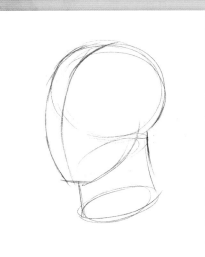

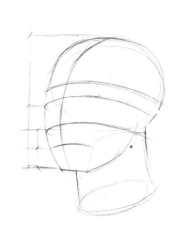

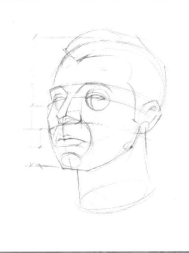

Step 1 First, very loosely identify the main shapes of the head and neck. Start with a circle for the cranium. Establish the center of the face, positioned to the left in this 3/4 view, and draw the chin, plus two lines and a circle for the neck.

Step 2 Now pay careful attention to the proportions of the features as you add guidelines for the eyes, nose, mouth, and ears. The head is slightly upturned, so the lines are rounded, reaching their peak around the center of the page.

Step 3 Following the guidelines, look very intently at your own features in the mirror as you block in the eyes, nose, mouth, and ear. Concentrate on the line drawing first. Don't worry about exact shapes, just try to get the general impression at this stage, and we'll refine it later. I've adjusted what I see in the mirror, making the ears slightly pointed and the hairline very pointed to make my self portrait more vampirelike.

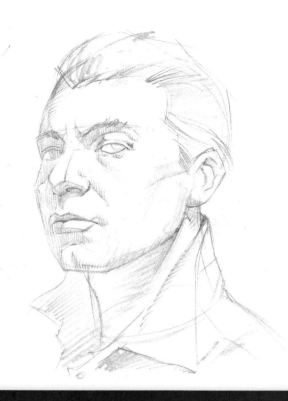

Step 4 The line art based on your reflection will be the basis for our future painting. Don't worry about how old you are, what cultural background you come from, or what language you speak; you're the perfect model no matter what, because vampires come from all different backgrounds. Now we are developing the details and adding the first impression of shadows. If you look at the masters' works, you'll see they use one point of light to produce a variety of soft shadows and one solid shadow on the opposite side; that's what we want here.

Strange Changes

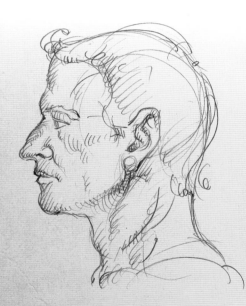

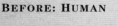
BEFORE: HUMAN

Although there are theories that some vampires are born, it's commonly accepted that most transform. Physically, humans and vampires are very much alike. But there are a few key physical differences between the species, other than what they eat to survive.

• *Vampires do not continue to age, but the wear and tear of gravity still affects them, so their noses appear longer. (They also typically get into tussles with some frequency, so broken noses and bumps are to be expected.)*

• *Dehydration affects the skin, as does the low-fat blood diet, so bones become much more prominent as the flesh of the face becomes less cushioned.*

• *We all know the teeth become sharp and pointy to aid blood-sucking, but so too do the ears enlarge slightly, sometimes even coming to a point, to aid in hunting.*

• *Finally, the hair and nails continue to grow after mortal life; the nails most vampires keep groomed, but the habit is to grow the hair, because it's a real pain finding a salon that stays open all night.*

AFTER: VAMPIRE

Vampire Pop History

Listing all the key events leading to the current popularity of vampires across the world would take a book in itself, but here are a few highlights:

1047 The word "upir" (later to become "vampire") is first recorded in Russia.

1190s Two authors give accounts of vampirelike beings in England.

1447 Count Dracula (Vlad Dracul) is beheaded.

1734 Following waves of vampire hysteria across Europe, the English word "vampyre" appears in translations from Germany.

1797 Goethe publishes a vampire-themed poem, "Bride of Corinth." Many more vampire poems (and even operas) follow.

1897 Bram Stoker's Dracula is published.

1922 Nosferatu, a German film based on Bram Stoker's Dracula, screens.

1931 An American Dracula film starring Bela Lugosi opens.

1956 The first Japanese vampire film appears, followed by vampire films in Italy and Mexico the next year.

1964 Both "The Munsters" and "The Addams Family" debut on American TV.

1966 "Dark Shadows" joins the vampire television family.

1976 Anne Rice writes Interview with the Vampire.

1992 The film Bram Stoker's Dracula is released.

1994 Tom Cruise and Brad Pitt star in the movie versions of Interview with the Vampire.

2005 Stephanie Meyer releases Twilight, which becomes a best-seller within a month.

2008 Twilight is adapted to film.

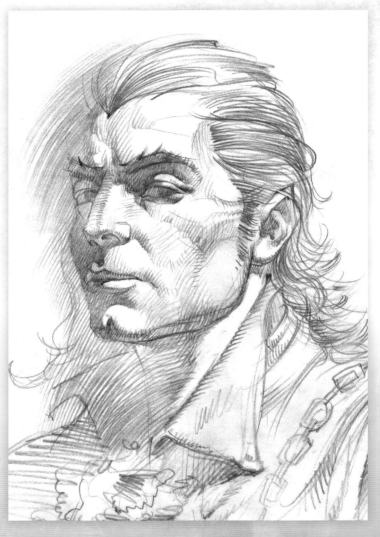

Step 5 Keep refining the drawing, deepening the shadows and adjusting the features to make them more vampirelike. I've added bushy, pointed brows and sharply defined cheekbones, plus a cleft in the chin, as these things are very aristocratic. I've also lengthened the hair, made the widow's peak even more prominent, and added a bit more pointiness to the ears. The clothing is representative of what someone in Rembrandt's era would've worn; you can look at his paintings for clothing examples, but don't feel obligated. Do whatever you like—this is your portrait, ultimately.

TRANSFERRING THE DRAWING

Although your drawing is a finished work in itself, our real goal here is to make a Rembrandt painting, so now you'll need to transfer the sketch to a canvas. If you choose to purchase graphite paper for this process, begin at step three.

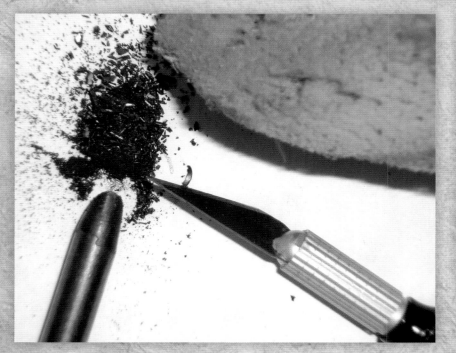

Step One You can buy graphite powder at an art store, but it's just as easy to make yourself by crushing a graphite stick with a utility knife.

Step Two Dip a sponge into the graphite powder, using it to evenly apply powder until you've covered an entire sheet of thin vellum or tracing paper.

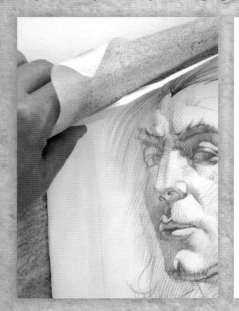

Step Three Layer the graphite-covered paper (graphite-side down) over your canvas, with your finished sketch on top.

Step Four Retrace the outline of your drawing, pressing firmly. Don't concern yourself with the shading and detail, just the main structure.

Step Five When you are done, lift the graphite sheet from your canvas. The lines you've traced will provide a guideline for your painting.

BUILDING THE PAINTING

As we're getting ready to move on to the painting stage, I want to take the opportunity to encourage you again to experiment. Experimentation—trial and error—is the best method for learning and mastering technique. I also want to encourage you to be like a vampire, meaning have patience. Because vampires are immortal, they don't worry about time. Well, painting in Rembrandt's style takes a lot of time, because we are placing one layer on top of another—and you'll need to have a vampire's patience to continue building up layer after layer. It's worth it in the end.

Step 1 To begin, mix burnt umber and burnt sienna with medium (see "Mixing the Underpainting") and begin blocking in the darker tones with a medium brush. Paint broadly, stroking in the overall impression of light and dark. You don't have to be precise at this stage. Just generalize the shapes and shadows.

MIXING THE UNDERPAINTING

To match the vampire's personality, you want quiet, dark, tones—deep browns and earthy shades, like dark grays and olives. We're going to be layering paints, so keep in mind "fat over lean": Your thinnest layers will be topped by the thickest later. For the underpainting, dilute your paints with two parts turpentine and one part drying medium so early layers will dry quickly. (See also page 82.)

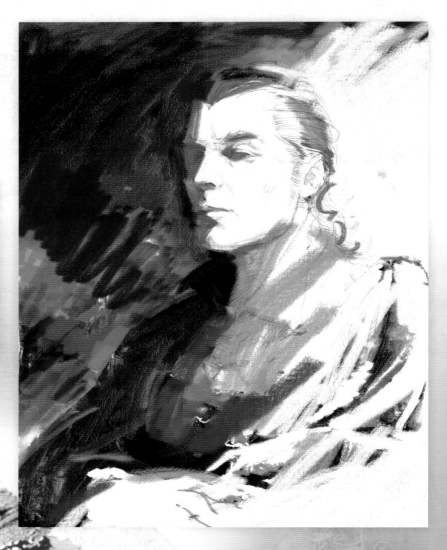

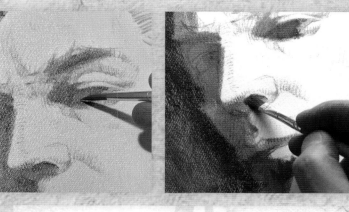

APPLYING THE UNDERPAINTING

By taking your time and developing the painting over multiple sessions, you can accomplish the most important goal: showing the deep hypnotic power behind the gaze of a vampire. When we map out and separate the shadows like we are doing here, we are setting the tone to mimic the feel of the self portraits by the great masters.

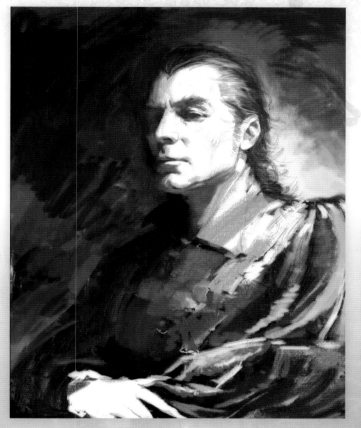

Step 2 After the first layer has dried, we're going to come back and build up more of the underpainting. This time, though, we're going to mix equal parts linseed oil, turpentine, and drying medium into our paint for a slightly thicker layer. The rich underpainting we're developing will show through and add depth to later layers, helping create the dramatic contrasts in light and dark we want to see in the final.

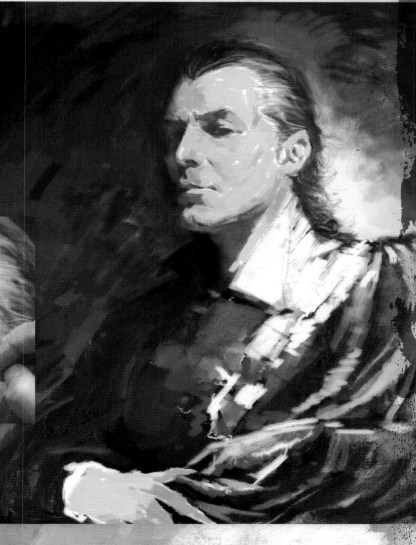

Step 3 Now, for the flesh tone, you want to mix three colors: a lot of white, some maple yellow, and a hint of cerulean or cobalt blue. You see, vampires are so pale that the veins show through the skin, giving it a bluish tint. Because we're still in the underpainting stage, you want to exaggerate this color slightly. And we're going to carry that cold blue tint into other areas, too, to give the impression of the moon's reflections in a nighttime portrait.

HIGHLIGHTING THE SKIN

Leave the white canvas for highlights in places; in others, add pink for dimension. Make forceful brushstrokes, strong and striking.

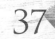

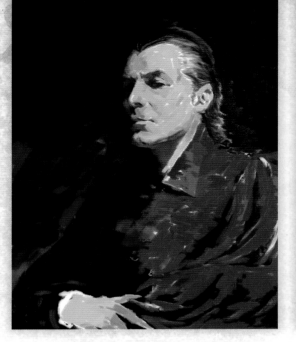

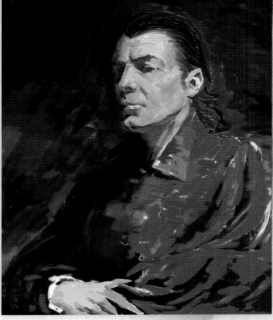

Step 4 We're still working on the under-painting, this time adding detail to the striking red coat, which is a thick mix of cadmium red and rose sienna with a hint of maple yellow. We place fiery red brushstrokes right on top of the underpainting where the light is hitting. The old masters really loved to add wrinkles to clothes to help increase tension and drama; to make all these folds approachable, it helps to think of them as simple shapes.

Step 5 Let the painting dry a few days before adding a thicker, more opaque layer of paint, with a little linseed oil mixed in. With a small brush, rework the flesh tone and lighter areas, warming them up. Define the features and wrinkles on the face, and develop the pointed hairline. Mix yellow ochre with white to touch up the darker area on the high cheekbones and temples. Also develop the background, going more neutral with a gray-blue.

Step 6 Make the background darker on the shadow side at left and lighter where it touches the vampire to add dimension. Make the hair longer and flowing. (Vampires really hate barbers.)

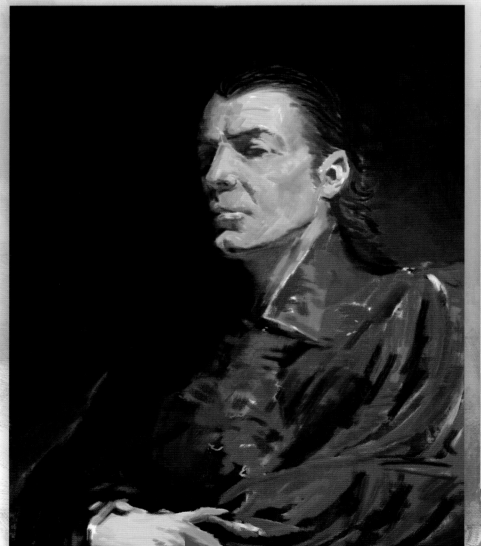

ADDING CLOTHING DETAILS

Work in some colorful accents—orange, green, violet, blue. They should be small, tiny touches on the canvas, but they'll bring more life and a more impressionistic feeling to your painting at this stage.

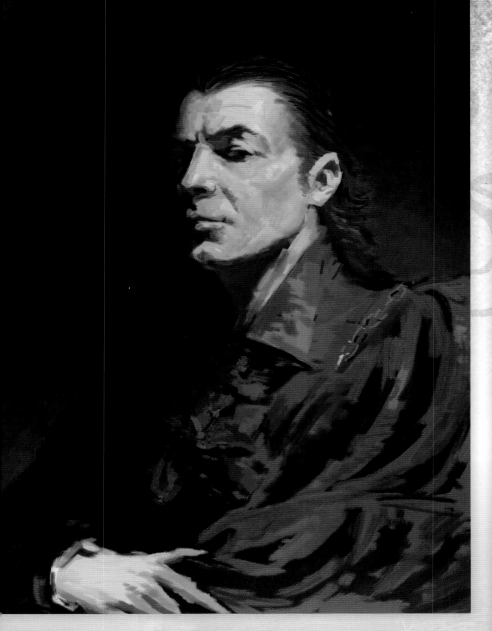

Step 7 Wait a few days for the paint to dry. Then apply copal varnish to bind the underlayer. (If you want to make sure your vampire stays in his frame, substitute garlic. The masters sometimes used it to bind.) Develop the lights, thick and firm—the opposite of Rembrandt's soft, uniform shadows. To add warmth to the foreground, mix cadmium red into light red. Use black and burnt umber for the background, adding oil and varnish medium for luster.

LIGHTENING THE FLESH TONE

Apply a mixture of light red, maple yellow, white, and still a little bit of a blue in certain areas of the skin—lightening the tone and still giving the impression that the veins are showing through his pale skin. Apply the paint with long, horizontal strokes to emphasize the roundness of the bone structures.

Background Elements

Not every vampire can afford a luxurious home, but the aristocrats among Rembrandt's patrons surely would have remote castles to call their own. Picturing your subject in his natural environs will help you as an artist, both in understanding the psychology of your subject and in adding background elements befitting his lifestyle.

MIXING SKIN HIGHLIGHTS

Move around the palette to develop the final skin tones. On the facial features, darken shadows with burnt umber. Give more weight to the whole head with yellow ochre. On the forehead and cheeks, apply pink and blue flesh tones.

DEFINING BACKGROUND ELEMENTS

Like in Rembrandt's work, we'll add background elements that don't draw too much attention but that complement the portrait. First we'll add subtle sky and mountains, starting with white mixed with cobalt and ultramarine blue for the sky. In the mountain areas, add a little green. Apply the color with a drybrush technique, using paint directly from the tube and a gentle touch. Then paint mountains with brownish, burnt umber, and black tones.

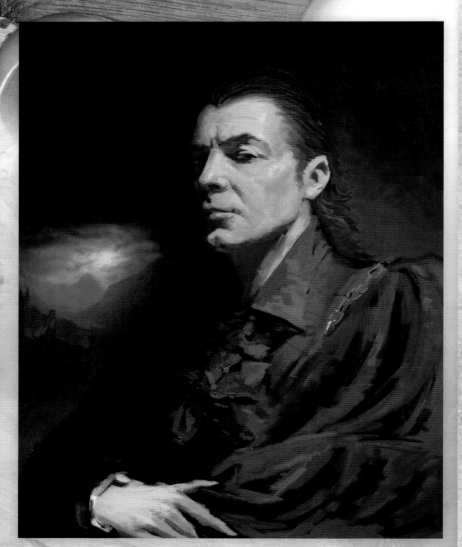

Step 8 With a small brush, reinforce the outlines of the figure, including the facial features. Then soften the shadows and lighten the tones of the skin and hair. Use a smaller brush to achieve a sort of delicacy in your brushwork, and show the line of the jaw and curve of the forehead and cheekbones by the direction of your brushstrokes. The dark underpainting contributes to the modeling.

ESTABLISHING FINAL DETAILS

Use a small brush to paint the Gothic church. This will help us establish the time period for the piece. The orange light in the window also helps balance the composition. Touch up the detail on the clouds with a little blending, using a fan brush for texture to finish.

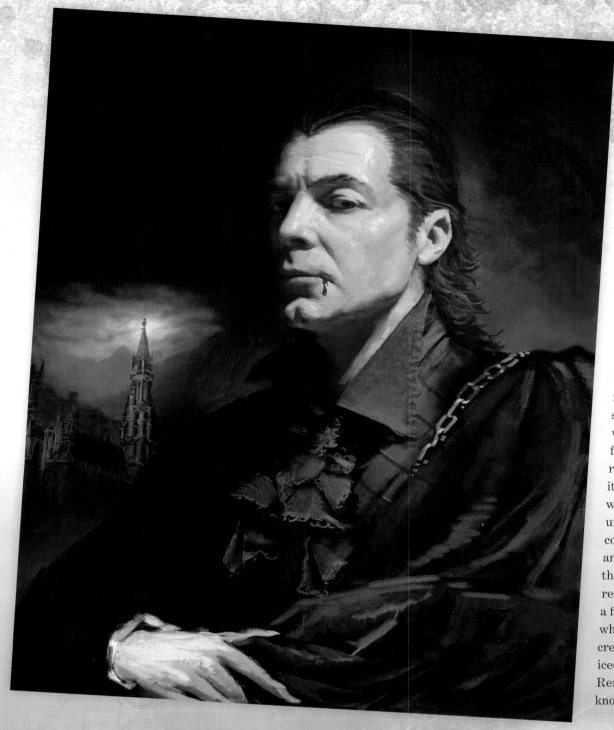

Step 9 There are still a few details left—cloud work and the Gothic spire in the background (see sidebar at left), a spot of blood for the vampire who has just finished feeding, and some almost-white highlights from the moon's reflection. Then it's time to wait a week or ten days, until the paint is completely dry and firm. When the painting is ready, you can add a final glaze that, when it dries, will create the kind of iced-over effect Rembrandt is known for.

FINAL TOUCHES

My vampire has dark, hungry eyes (vampires' eyes are always darker when they are hungry; it is a known fact), but he wears a very satisfied look, so I added a trickle of blood at the corner of his mouth, as if he'd just finished a feeding— perhaps a light snack.

FINISHING GLAZE

For the final glaze after the painting is complete and dry, mix one part oil copal varnish and one part turpentine, and add just a little burnt umber. With a large flat brush, carefully apply the mix over the painting, first in a horizontal direction, then in a vertical direction. Now let gravity do its job. The mix will seep into the canvas pores and create an even layer.

41

STUDYING MICHELANGELO'S STYLE

H ere is one of the greatest artists who ever lived, a man whose name has become synonymous with the word "masterpiece," Michelangelo Buonarroti (1475–1564).

Michelangelo was born in Italy and raised in the city of Florence. His dad was a government agent, and his mother passed away when he was only six years old. Although the young master always was interested in art, his father didn't want him to study it, as he thought it "beneath" the family's standing in society. Michelangelo persisted, though, and eventually got his wish. At the tender age of thirteen, the young artist became an apprentice to a local painter. A year later, when his internship ended, he was looked after by a well-known sculptor, staying with the retired man's family and gaining access to an incredible array of artwork for his study.

Michelangelo was recognized as a sculptor before he was revered as a painter. His attention to detail and appreciation for the beauty of the natural form were both apparent in what is perhaps his best known sculpture, David. *Featured at left:* David *(copy) at Piazza della Signoria in Florence, Italy.*

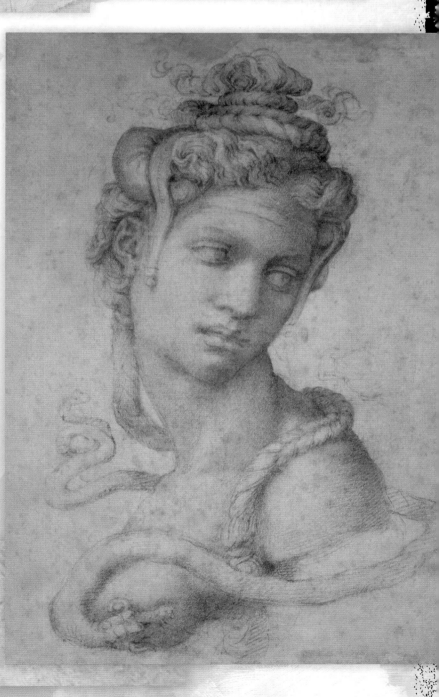

Michelangelo was asked to paint a simple portrait of the twelve apostles on the ceiling of the Sistine Chapel, but the master's vision was grander, and he created many biblical scenes, including God's creation of man, a familiar portion of which is pictured here.

Hands of God and Adam, detail from The Creation of Adam, from the Sistine Ceiling, 1511 (fresco) (pre-restoration), Buonarroti, Michelangelo (1475–1564) / Vatican Museums and Galleries, Vatican City, Italy / The Bridgeman Art Library International.

He started working on his own art at a very young age, creating remarkable works of sculpture when he was still a teenager. Although he was known mostly for his sculpture work at that time, Michelangelo also was hired by his wealthy patrons to create many different types of art commissions. And in 1508, Pope Julius II himself hired the master to paint the ceiling of the Sistine Chapel, an artwork that is considered legendary today for its scope and detail, as well as its grandeur and emotion.

Michelangelo remained in Italy and kept creating art up until his death, although he found himself more dedicated to poetry and architecture later in his life. He lived a very long life, especially for someone of his era.

It's helpful for students to study Michelangelo because he was a complete artist. In order to create a sculpture or make a painting, he had to do a lot of preparation, including many drawings and sketches before he ever touched a chisel or brush. As a student, you can learn from these preparation materials how Michelangelo developed complicated three-dimensional depictions from start to finish. It's like getting a peek into his thought process.

And Michelangelo was a true Renaissance man, both in respect to the period in which he lived and the variety of his art. He loved beauty in all its forms, so of course we expect he would've had a great appreciation for the majesty of vampires. And if anyone could capture the powerful spirit of these awe-inspiring powerful ancient beings, it would be a genius like Michelangelo.

Michelangelo made many, many sketches before embarking on any work. Unfortunately, few of those preliminary drawings have survived for us to study and appreciate.

Cleopatra (69–30 BC) (charcoal on paper), Buonarroti, Michelangelo (1475–1564) / Casa Buonarroti, Florence, Italy / The Bridgeman Art Library International.

PREPARING A TEXTURED PAPER

In the modern day, we think of paper as naturally white. But in fact, the paper we use goes through a bleaching process to make it so pure and light. During Michelangelo's time, artists would bleach their own paper, creating a yellowed base. That yellowing brings a certain sense of beauty to the drawings, as well as a visual texture; to achieve that, we're going to take our already-bleached modern paper and make it less perfectly white, the reverse of what a master like Michelangelo would've done, but with the same end result.

Coffee will keep you going as you work, and it also will come in handy for yellowing your paper. You'll need a nice smooth Bristol paper for this process, too, along with salt and a wide brush. To be prepared for the next stage, break out your pencils (colored ones, too, plus sepia and sanguine varieties), pastels, charcoal, and any other drawing materials you have. We'll use those once our paper is ready.

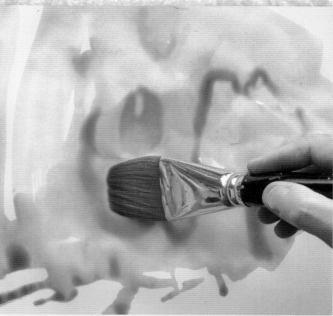

Step 1 The main coloring agent for our smooth white paper will be coffee. Coffee is everywhere, and although vampires much prefer blood, even they have a caffeine habit. (After all, modern vampires need help to stay awake during their night hunts.) So, brew some coffee, let it cool, and then carefully pour a small cup of the liquid over your paper. (You might want to do this over a sink to control any mess.)

Step 2 Swirl the coffee around on the paper using a sable brush. Move your brush around the paper using both horizontal and vertical strokes. Be very gentle, because if you apply too much pressure, it may damage the paper. The color does not need to be even. Actually, as the paper curls, more pigment will collect in the dents, and that will create a nice marbled effect.

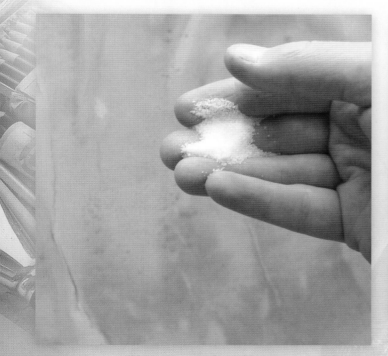

Step 3 Now we'll be using regular table salt to absorb the excess pigment and create interesting spots on the paper. When the shine has left the paint but the paper is still damp, sprinkle about an ounce of salt evenly over the surface.

Step 4 Let the paper dry for a couple of hours on a level surface. The salt will attract pigment, leaving a dark ring around the edge of each granule; so once the paper is dry and the salt is removed, there will be a little light spot at the center of where each particle was.

Step 5 As the paper dries, the pigment will begin to even out a bit, leaving little spots of texture around the grains of salt. The marblelike pattern that results will mimic the age spots on a Michelangelo drawing.

Step 6 Once the paper is completely dry, break up the areas where dry salt is stuck stubbornly to the paper; you can prevent damaging the paper by crushing the encrusted salt using a razor blade. When it's all broken up, we're going to sweep away the salt.

You can prevent damaging the paper by crushing the encrusted salt using a razor blade.

Step 7 Now use a brush to sweep most of the salt off the page. (It's important to remove all the salt before we draw or paint, because it's possible that it would eventually cause some sort of unpleasant reaction with the air—or even with the vampire's chemistry.)

Step 8 Just to make sure we've gotten all the granules, we're going to soak the paper in plain water (a large sink or the bath will do just fine). Let the paper soak for a bit so as to completely dissolve any leftover salt, along with any excess stain from the coffee.

Step 9 Next place the paper on a smooth surface (like a glass tabletop) to roll it flat. Let it dry—or take it outside into the sun to speed things up. (There's no vampire on the paper yet, so it won't turn to ash.) If the paper curls slightly as it dries, just roll it flat again.

Step 10 Rather than just waiting on the air to do its work, you can help the drying process by blotting up excess moisture from the paper using a paper towel or light cloth. This process also may absorb some final bits of pigment from the paper, enhancing the textured appearance.

FINAL PAPER TEXTURE

When your paper is completely dry, you have a beautiful "bleached" paper that's ready for your vampire masterpiece. Let's begin drawing!

The Female Vampire

Although male vampires tend to hog the spotlight, female vampires have been quietly hunting their prey since the beginning of time. The Greek lamia predates most male vampire tales, and the Scottish Baobhan Sith also have a long and rich history of seducing males. There are many more examples from just about every culture—but perhaps the most fascinating of these is of an aristocratic woman who, much like Count Dracula, found immortality in her infamy.

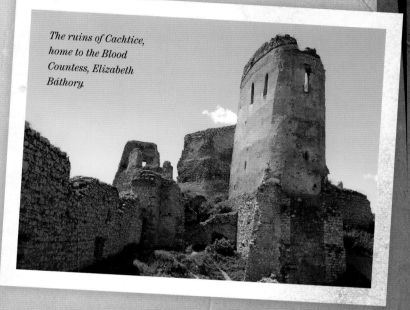

The ruins of Cachtice, home to the Blood Countess, Elizabeth Báthory.

The woman of whom I speak is Elizabeth Báthory, a Hungarian countess who lived with her husband in the Cachtice castle (located in what is now Slovakia).

In the war against the Ottomans, her husband acted as chief commander of the troops, while the smart and capable lady stayed home and defended their estates. Because of her husband's prominent position, Elizabeth enjoyed some protection and privilege under the law. It is unknown when she started to abuse this protection, but her actions would come to light after her husband died in battle.

At about the same time as her husband's passing, reports surfaced about unusual activity at the castle.

Báthory was eventually tried, and many gruesome details came to light about her behavior. Reports were that she disciplined young women by beating, torturing, starving, or even biting off flesh. These behaviors began with young peasant girls who were paid servants at the castle, but later extended to young lesser noblewomen as well as girls abducted for the countess.

Although the trial focused primarily on the torture and deaths (said to number as high as 650) of the girls, rumors were rampant that the countess also used the young women for another purpose: after killing them, the countess would drain their blood, bathing in it to maintain her youth. It is this legend, not her sadistic torture, that persists into the modern day.

Because of her nobility and the importance of her family (who at the time ruled over Transylvania), Báthory's death sentence was commuted to life imprisonment in the castle Cachtice. She remained locked up there until her death four years later—but her ghost is said to haunt the castle ruins still to this day.

ESTABLISHING THE FIGURE

Michelangelo's approach to painting was different from Rembrandt's. His work was almost like a colorful drawing, or even perhaps the equivalent to early comic books. In particular, the Sistine Chapel is basically a big collection of comics, panels illustrating the bible through a series of powerful images. One of those biblical stories involves the Sibyls—prophetic women who foretold the coming of Christ—and that's what we'll be using as our reference for our female vampire portrait.

Five Sibyls, or prophetic women of the ancient world, adorn the Sistine Ceiling. This one, the Delphic Sibyl, projects an aura of strength and mystery.

Sistine Chapel Ceiling: Delphic Sibyl *(fresco), Buonarroti, Michelangelo (1475-1564) / Vatican Museums and Galleries, Vatican City, Italy / The Bridgeman Art Library International.*

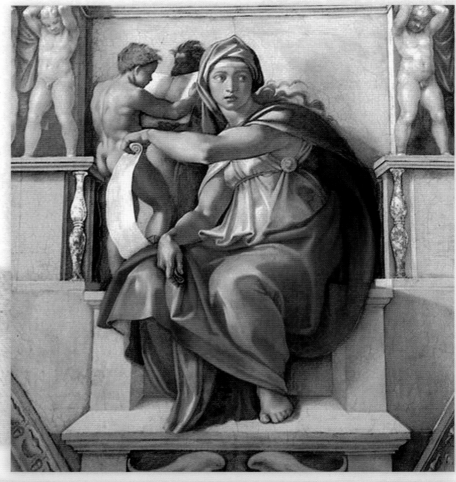

MIMICKING AN ENGRAVING

Michelangelo's drawing style produced a result that was actually very similar to the look of an etching, the style or portraiture you'll see on money around the world. Take a close look at this old Russian currency, for example—or peer closely at George Washington on a dollar bill. You can see how detailed and meticulous the shading is. The lines are curly rather than straight, and they're following the shape of the figure. The lines are also dark, but they have only a certain grain or direction, so the tone and detail of the form is controlled.

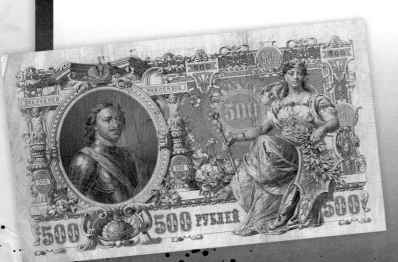

Practicing Pencil Techniques

The best way to become better at drawing is to practice—not just by drawing complete subjects, but also by practicing the simple techniques, such as various kinds of pencil strokes. For now, practice these different strokes to warm up, and then come back to them later to practice more and help improve your technique.

Before you begin making strokes, you must first learn to grip your pencil. The traditional overhand grip is probably already familiar, but it never hurts to practice for times when you need maximum control with a new grip—the underhand. Take either a sepia or sanguine pencil and apply an underhand grip, holding the pencil close to the point. This will make it easier to produce the short, dark strokes of Michelangelo's drawing style.

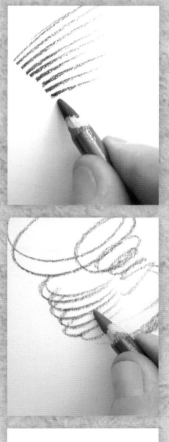

Stroke 1 These strokes start dark but fade away. Press firmly into the paper, and then release the pressure gradually until the line disappears. The gentle curving motion creates movement and shading. Move from top to bottom and find your rhythm to evenly space.

Stroke 2 These curling strokes are characteristic of Michelangelo's work. The round shape helps create form and give dimension to objects you're shading. Focus on controlling the firmness of each stroke while making an incomplete circular motion with your hand.

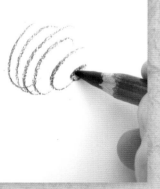

Stroke 3 For a spiral effect, start from the center and circle around, relaxing pressure and lifting off the paper as you reach the base of each stroke. Experiment with the distance between lines. A narrow distance between strokes will create darker shading.

Combining Strokes A small stroke may seem like nothing when it stands on the page alone. But when you combine a number of small strokes and learn to make them precisely . . .

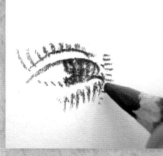

. . . you'll soon be creating varied detailed images. This eye is simple a mix of the various short strokes you've been practicing.

Sharpening Points Traditional pencil sharpeners are fine for art pencils, but many artists prefer other methods of creating a point, ones that give them more control. You can use sand paper to make a fine point on your pencil, of you carve with a razor blade to achieve a variety of blunt pencil points, as shown here with a sepia pencil.

CONTROLLING THE LINE

Michelangelo was a genius when it came to understanding and depicting human anatomy. And he left us his sculptures, frescoes, and drawings to study and learn from. Just as Michelangelo made many sketches and studies before he began a major artwork, we're going to start our vampire portrait with a simple figure study. As you draw, pay close attention to the elements—the joints, the limbs, and so on—both the placement and the size relationships, or what we call "proportions."

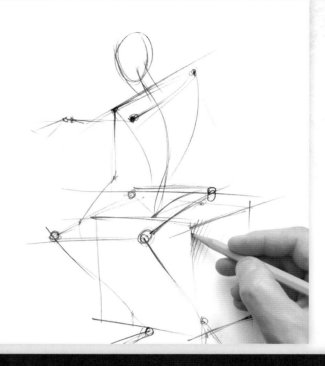

MIDLINES

Start your drawing with the midlines of the body, lines that go through the middle of body parts, such as the spine of the body or the bones at the center of the legs. Basically, what we are doing here is mimicking the structure of the skeleton. Use a sharp pencil and make firm lines, creating tiny circles to indicate the joints. Create as many drawings as you need until you are satisfied with the base of the figure.

Bat Basics

We've been focusing on the human shape of the vampire. It's important to remember that vampires are shape-shifters, though, and you may come across a vampire in the form of a bat or in the shape of another animal (depending on what geographical region you're visiting). Approach these other vampire shapes the same as you do the human form, starting with the structure underneath and then building up the form.

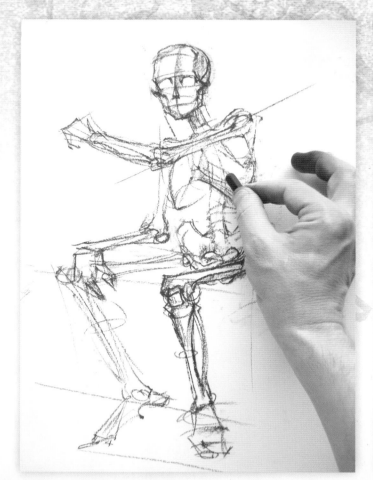

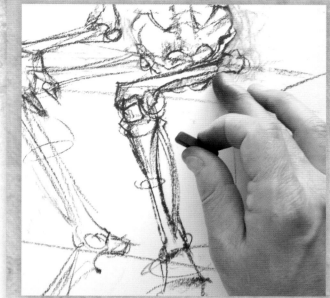

BLENDING

When you draw with a sepia stick or pastel, you can achieve a lot of variation in tone. Use the side of the stick for broad lines or the tip for thin marks. Vary pressure to make your lines thicker or thinner. Just remember that lighter marks are easier to adjust. You can use your finger to even out lines, blend them, or even make them disappear. Drawing over the blended spots of sepia can create interesting shadow effects.

SKELETAL STRUCTURE

Continue on top of your midlines to work out the skeleton of the figure (or retrace your midlines on a new sheet of paper, if you wish). Now I'm going to render a loose skeleton in sepia pencil so that I understand what's underneath the skin and making the form of the body I'll draw later. You don't have to get this detailed, but this is what Michelangelo would've done. Referencing the midline drawing, I make sure everything is in position and proportional.

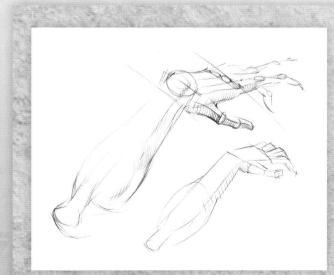

VAMPIRE ANATOMY

Anatomy poses a challenge to most beginning artists, but it doesn't need to be intimidating. Just think about the basic shapes of each piece of the body separately, such as the rectangles of the fingers or the cylindrical shape of the forearm. Starting with these shapes and then refining them can make the drawing process more manageable.

VAMPIRE HAND IN PERSPECTIVE

Even a angled body part that is distorted because of its viewpoint is easily approachable if you draw what you see, starting with the shapes underneath and building to develop the form and render the detail.

53

GESTURE DRAWING

I've switched to a new sheet of paper and a graphite pencil for the next step, but essentially I am building on what I've already drawn—just as the skeleton is built atop the midlines, this gesture drawing works around the basic form of the skeleton. (You may even wish to create it on tracing paper that is laid over your midline or skeletal sketch.) Over the framework, use curly lines to build up the muscles and the body itself, establishing the shape and form of the body while enhancing some of the design elements, such as creating a sense of rhythm and movement with the fabric of the clothing to complete the figure.

EXPRESSIVE CONTOUR

Now let's practice using our sanguine stick before we move on to our final drawing. This "pencil" is a particularly appropriate choice for a vampire illustration because the word "sanguine" means "blood red." Your contour drawing should almost look like an X-ray of the figure. Try to combine gently rounded, curly, and straight lines together, but don't worry about trying to mimic the Michelangelo style exactly. Don't be afraid to do something wrong. You can always correct yourself and add stronger, firmer lines later. Define the special forms and refine the movement and pose itself.

Step 1 Now with your contour and skeletal drawings on hand for reference, let's begin the final artwork. Use the sanguine stick and center your drawing on your paper (which should be plenty dry by now). You can resketch from scratch, or you can use a lightbox or a sunlit window to trace your foundation drawing from an earlier sketch. Define the outline and silhouette, where all the important elements join, and the edges of the clothes.

ROUNDING LINES FOR FORM AND VOLUME
As you apply very thin, soft lines, gently try to emphasize the roundness of the forms and the volume as much as possible.

Step 2 Now establish the direction of the light—which is coming from the top left of the image—by strengthening shadows on the opposite side (or the bottom right) using firm, curly strokes. Because you're using the sanguine pencil, variation won't be as great as it would be in black and white; so even though the light and shadow is fairly well differentiated, everything is still in the same middle tone. When you're working your shadows, focus on the edges and corners where elements connect to one another, especially where we see wrinkles and folds. But at this point, things are still general, so don't worry about tiny details yet. That will come later.

MAKING UNIFORM STROKES
Stroke consistency is important. In the more shadowed areas, the lines should be much more defined and very straight and strong.

Step 3 Working from the top of the paper down, slowly build up the details. You're revealing the figure in the drawing through shading, which is also creating the form. Even though we're working in sanguine, our technique is similar to that which Michelangelo used for the Sistine Chapel: developing one square inch at a time. Work slowly and carefully. When you're working with pastel or sanguine, you're using a "soft" material drawing technique, so you want to be very gentle with your pressure. You also want to prevent accidental smudging; moving slowly from top to bottom helps you avoid smearing your work.

Step 4 As you continue working down the page, begin to add details to the wrinkles. Use rough, round strokes in combination with very precise, small, direct strokes as you continue building more tone. You can still leave some elements unfinished, but completely render others, such as the rosette ornament on her clothing beneath her arm. Keep going. If you stop, you will have to warm up your hand again, so it's best to do this all in one session, when you have the rhythm and the muscle memory working in your favor.

57

Step 5 Now that we've reached the base of the drawing, if you're left handed, you're going to be moving from left to right (again, to avoid smudging your artwork). Keep your hand hovering above the paper as much as possible, not resting against it. (I know this gets hard as you get tired, but the result makes it worth the effort.) Each line drawn at this stage should be clear and distinct, especially in the dark areas.

Step 6 Now strengthen key areas using a little more pressure from your pencil. Define the darkness at the edge between the light and shadow, as well as her elbow and knee area and those creases on the clothes. To ground her and add depth, define the shadow under her feet. Keep the background simple, adding some light lines to separate the figure from the background, giving it the feel of a relief sculpture, like something Michelangelo would create. And you're finished! Frightening—but beautiful.

APPLYING A FIXATIVE

Since sanguine is so soft and delicate, you'll need to use a fixative to keep it on the paper when your drawing is complete. You can use any conventional fixative for pastel, charcoal, or pencil, as long as it's not too glossy and won't yellow your paper. However, the French impressionist masters would've mixed eight ounces of skim milk with three teaspoons of sugar! You can do the same—it's a great way to get other family members involved in your art! Apply the solution using a conventional sprayer from an art supply store or insert two straws through a wine cork at a 90° angle, placing one end in a glass of milk and blowing through it to create a film across your drawing. It can take a bit of practice, so be gentle at first.

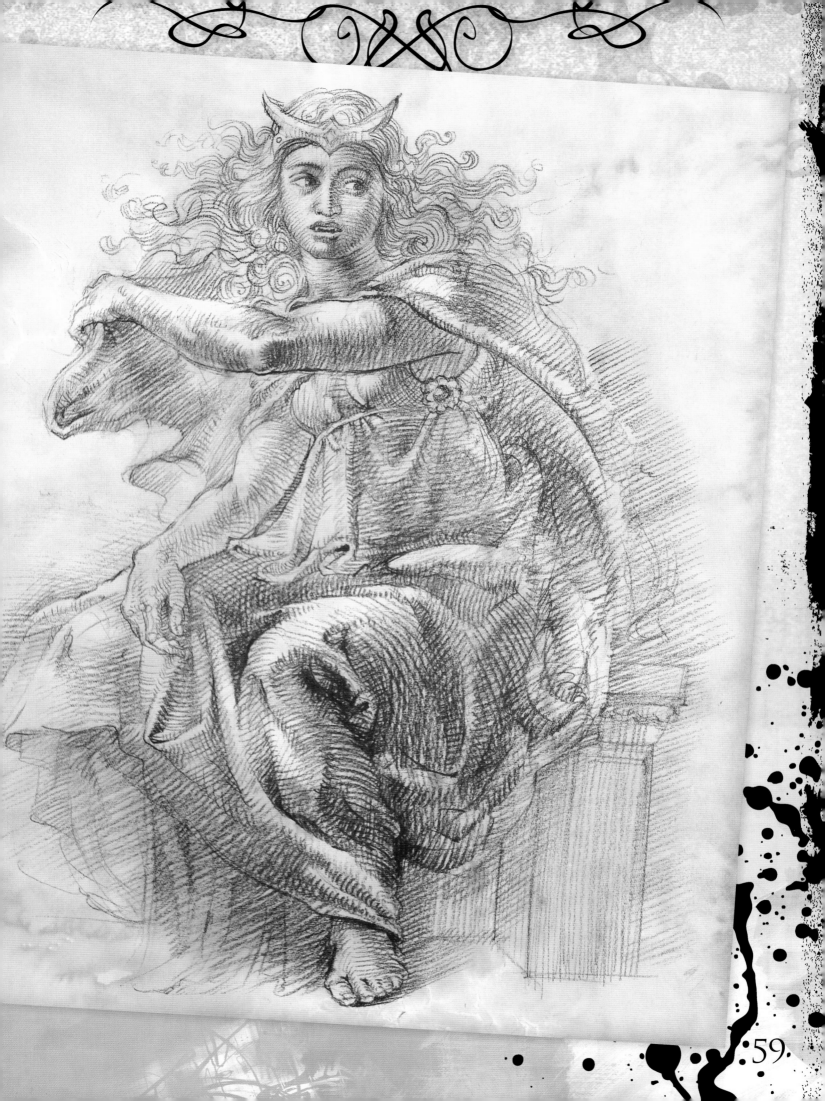

STUDYING SEURAT'S STYLE

Georges-Pierre Seurat (1859–1891) had a very typical upbringing. The son of a comfortably well-off legal official and a quiet but warm mother, Seurat spent his early years in Paris. He began studying art as a young man, but his education was interrupted by war, and he served a short stint as a soldier before returning to both Paris and painting.

Although often grouped with the impressionists, Seurat is considered one of the founders of "neoimpressionism" by many because his experimental art moved beyond the impressionist principles. His works were deceptively simple, with subjects that appeared uncomplicated at first glance, but which were made up of layers and layers of tiny overlapping dots of color, a painting technique he developed called "pointillism." With this method, the colors aren't blended on the palette and then applied in strokes. Rather, the canvas is covered in tiny, intricate dots of overlapping color; when viewed from afar (or when the eyes are squinted and unfocused for an up-close viewing), the colors appear to blend visually.

Although most of Seurat's work focused outdoors, and therefore was light and airy by nature, there was a certain sense of isolation to his work. And the tall, handsome artist also had a reputation for being serious, intense, and most of all secretive. For these reasons, he's a good choice for a master on which to base a vampire portrait!

Seurat spent two years working on his most famous painting, a mural-sized work called *Sunday Afternoon on the Island of La Grande Jatte*, which is demonstrative of the complexity of his work. Despite the simple-seeming result, the finished piece contains immense amounts of thought, planning, and detail that can be best appreciated when viewed up close. The artist worked up more than 200 sketches and oil studies before unveiling the final work, which was one of only seven major paintings he completed before his death from exhaustion at age thirty-one.

The tall, handsome artist also had a reputation for being serious, intense, and most of all secretive.

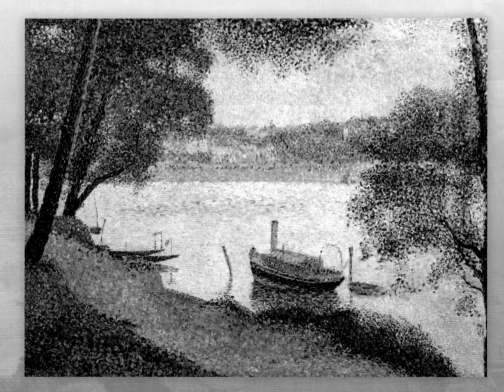

***River Landscape with a Boat**, Seurat, Georges Pierre (1859–91) / Private Collection / Peter Willi / The Bridgeman Art Library International / oil on canvas.*

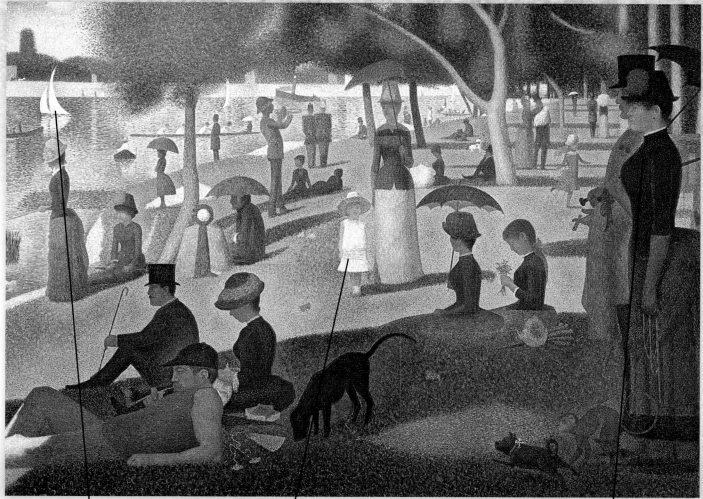

Sunday Afternoon on the Island of La Grande Jatte, *1884–86 (oil on canvas), Seurat, Georges Pierre (1859–91) / Art Institute of Chicago, IL, USA / The Bridgeman Art Library International.*

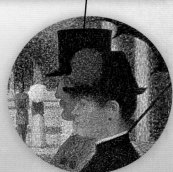

REPRESENTING A VAMPIRE

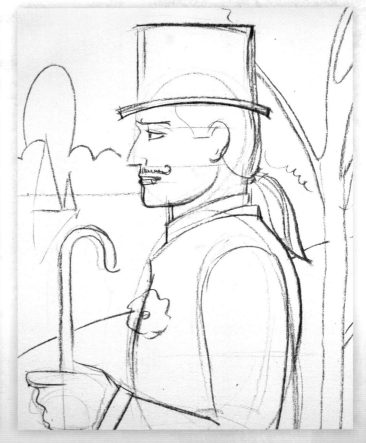

Step 1 We are going to start with a very simple composition, drawn on a piece of standard-size board-backed canvas. Relax your mind and your hand. Then with a small piece of soft black charcoal, establish the general figure of the vampire—a basic silhouette. Don't go into too much detail or add shadows at this stage, just take about five to ten minutes to get the outline in place.

Step 2 Next we'll add a few vague details to the drawing—the clouds, shadows, and general background and environment. Impressionists worked mostly outdoors rather than in the studio, so their paintings usually include natural elements, like sky and water. There's a sense of life in impressionist scenes, with animals and plants and such. Our vampire will be in dramatic contrast to that feeling.

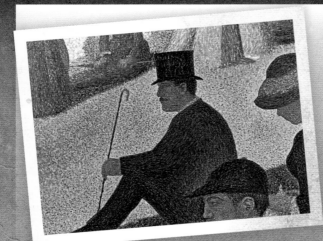

ANALYZING THE FIGURE

If you look at examples of Seurat's work, you'll notice that his figures are very simple. They almost remind me of puppets or dolls, made up of very simple geometric shapes. The inspiration for our vampire portrait came from one of these vague, simple figures, from the one lonely gentleman who sits in a shadow in a top hat. He looks like a normal enough guy, but his dark silhouette suggests that if you look very closely, psychologically, he could be very vampirelike.

BRUSHING DOTS

Before we add paint, we're going to dust off the excess charcoal with a large brush. This is an important step, because we don't want charcoal to mix with the water-based paints, creating ashy colors. Just gently brush off the loose charcoal with a dusting brush before you begin.

MAKING THE CONTOUR

Now that we're completely happy with our base drawing and we've gotten rid of the extra charcoal dust, we're going to begin dotting on ultramarine blue mixed with a little water, using a small brush to apply the color along the charcoal lines. This is a quick, one-sitting painting, so we'll use acrylic, which dries fast.

PALETTE PREP

For this project, we'll be using colors you would find in a nature scene, like yellows, blues, and greens. Unlike the neutral and dark palettes of our previous portraits, the Seurat painting will have a brighter feel—in direct contrast to the brooding vamp.

63

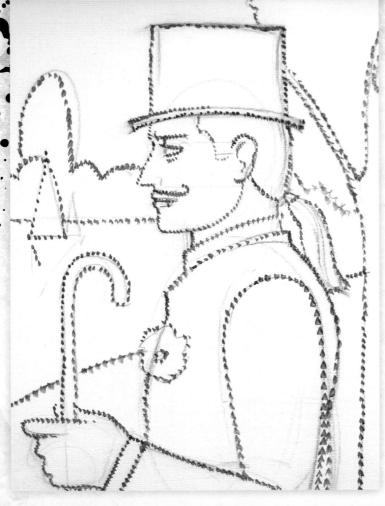

WASHING WITH A SPONGE

When the contour dots are dry, you can use a soft sponge and a little water to completely wash out the charcoal from your canvas, leaving only the paint behind. We don't want to see charcoal when you're done; this line of blue dots will be our only guideline for our later layers of the painting.

Step 3 Continue placing consistently spaced and sized dots all along the charcoal lines of the initial sketch. Work on a flat surface, so that the paint dots don't drip with the pull of gravity. When the blue dots are all in place, let the paint dry completely. Because we're working with acrylic, it will be dry in no time, probably ten minutes.

Step 4 Next we're going to apply a brown color. You can use Mars or burnt sienna; either one will work fine, just mix it with a little water to dilute the color a bit. The brown is really just used to build up the tone, laying the ground work for both the three-dimensional effect and the shadows.

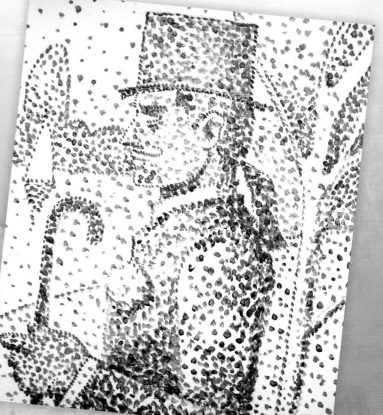

MAKING DOTS

Apply the dots with a vertical motion. Each dot doesn't have to be completely perfect, because you're going to be putting many dots over one another, but consistent sizing is helpful. Just try to find a medium size that works.

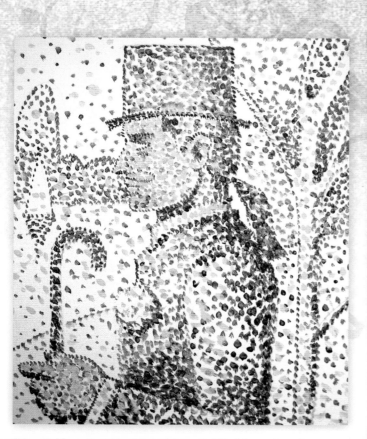

Step 5 Now that the brown tone is filled in and we have the shadows, we're going to start mixing up Naples yellow with water so we can establish the lighter areas. We'll be covering the light parts of the body with that yellow. Between the brown and yellow, our foundation is pretty well established.

BUILDING TONE

You can always add more color later if you find the spacing isn't right, but we're going to be layering on color, so don't worry if everything's not exactly perfect at this stage. Not all my dots are perfect circles, and the spacing varies a little. It's okay if your strokes vary, too.

Detecting Vampires

Because so many vampire species have much in common with humans, it can be difficult to tell if what you're observing in a cemetery is a corpse or something truly undead. Look for these disturbances to detect if a vampire is present:

- *Freshly turned earth*
- *Persistent mist*
- *Creaking or groaning sounds from the earth*
- *Askew or opened coffins*
- *Toppled tombstones or crosses*
- *Footprints leading away from the grave*
- *Quiet (no bird song or bug sounds)*
- *Dogs and horses wary of entering*
- *Corpses with open eyes and ruddy complexions*
- *Blood around a corpse's mouth, a coffin, or a tomb*
- *Presence of an overly protective caretaker*

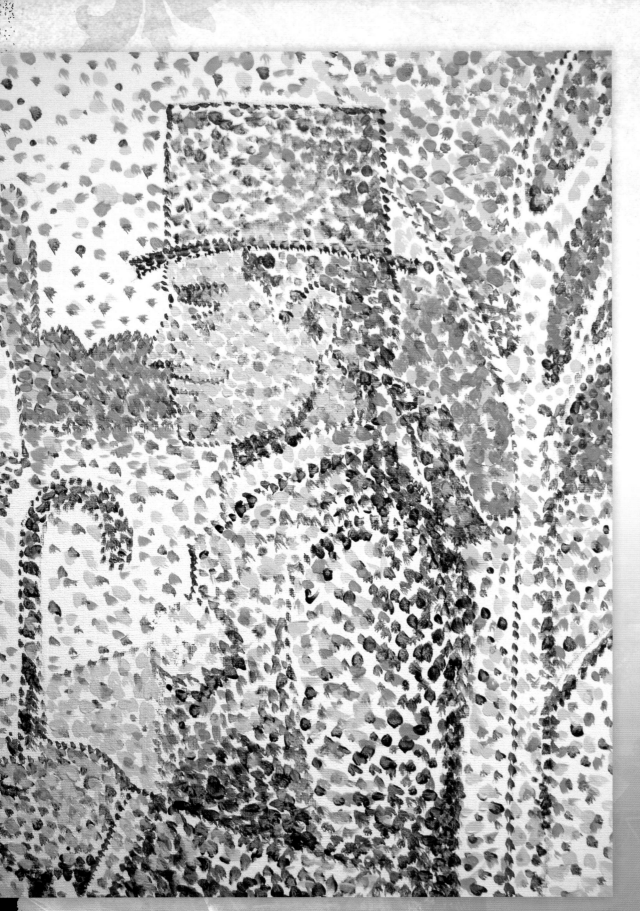

Step 6 Like we talked about earlier, Seurat's paintings, like those of all the impressionists, depict a lot of nature, which means a lot of greenery! It doesn't really matter what hue(s) of green you apply. You're welcome to use some of them or all of them. Much of the vibrant green is going to be covered by red and blue and such later, and the eye will blend everything together to create entirely new colors when the painting is complete.

Hair of the Ages

You may have noticed that our Seurat vampire once again wears his hair in a long ponytail. Although all vampires prefer longer hair, they wear it in many styles, often reflecting the era in which they are originally from. For example, whereas medieval aristocrats wore well-kept coifs, modern vampires—not unlike modern youth—are often inspired by Japanese manga. Here are a few examples you might apply to your portraits.

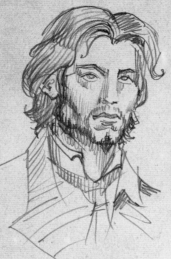

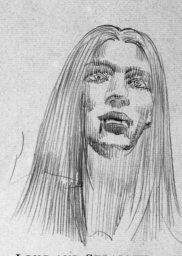

BED HEAD

The impish "just rolled out of the coffin" look. Very low maintenance, making it ideal for vampires on the go.

SHAGGY WAVES

Because it suits the eighteenth century as well as it does the twenty-first, this wash-and-go look is a popular classic.

LONG AND STRAIGHT

An alternate look for pony-tailed lads, this straight center part was popularized in the 1970s and remains trendy today.

LAYERED LOOK

Vampires are notoriously vain and like to highlight their best features; this style flatters by emphasizing the bone structure.

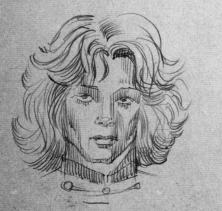

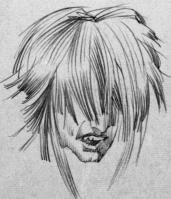

WIND-BLOWN

Stopping just short of the '80s feathered 'do, this airdry style is free-flowing and stays out of the face (and fangs).

MODERN CHOP

This chunky, angled cut hides the face and emotions, making it street chic and popular amongst the younger set.

AU NATUREL

Not every vampire adopts a personal style—some ladykillers embrace their inners selves, simply letting their hair go natural.

MIXING COLOR FOR SKY

In the natural world, the color blue is everywhere—it's the dominant color of the sky and the water, and it's reflected onto everything else, too. That's probably why blue is a favorite of impressionists. Seurat used a lot of (then very expensive) ultramarine blue; we'll use the same (it's cheaper now), but we'll mix it with white or cobalt blue or cerulean blue in different places.

BUILDING UP SKY COLOR

Just go ahead and cover the sky with different blue mixes. As you build up the color, remember that the sky is very blue, and more purely so, meaning it's okay to add a lot of dots and place them closer together, as we won't need to add a lot of other colors here..

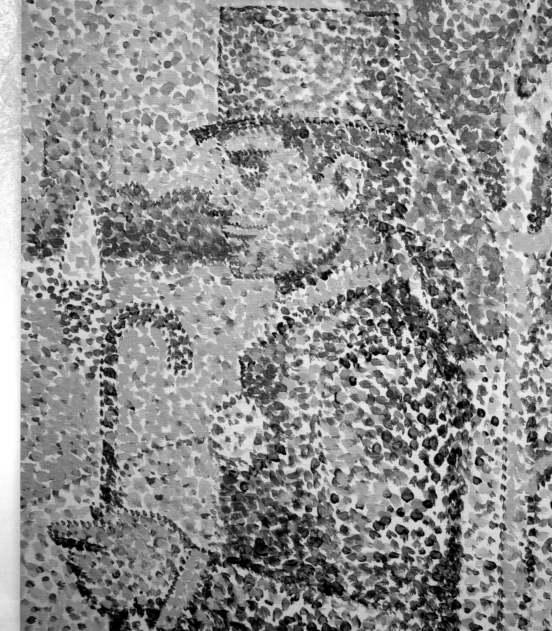

Step 7 More of those same blue mixes get dispersed all over the entire canvas, not just in the sky and water. They go everywhere—up the tree, on the figure, even on the white boat sails. It's okay to overlap some of your existing strokes as you apply more dots.

BLUE IN THE FACE

Yes, there really is blue everywhere! It's on the vampire's coat, on his cane, on his hat—yes, even on his face. (We would add blue to a regular man's face in a pointillism piece like this, but it's even more important for the pale vampire, as the blue will help give the impression of his paleness and coldness.)

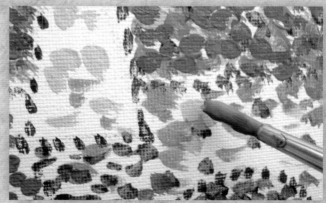

BUILDING WATER

You'll notice that the blue dots are closer together in the very blue areas, like the sky and water. You can shorten up the distance between the spots of the color in areas where you think a particular color should be more prominent. Here we're doing that with blue on the water; later we'll be doing it with other colors, like red.

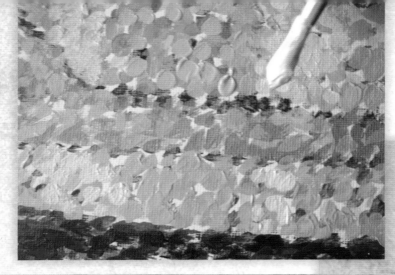

BUILDING DIMENSION WITH OVERLAP

As you build up your painting, the more dots you apply, the more overlap you're going to achieve. That's okay, and it's also okay that the white of the canvas is still showing in places. This is helping us build the dimension of the painting, and it will also helping the viewer visually blend the colors when looking at the painting.

APPLYING RED AND ORANGE

We're going to start experimenting with different colors at this stage. Go ahead and start infusing reds and oranges. (The colors don't have to be pure; you can grab a little of the neighboring color on the palette to give the painting more variety.) The red colors will give us that hint of blood, something we'll want to play up on the vampire's lip area, of course, as we would be able to see spots of blood still there from his last feeding.

CARRYING THE THEME

We're going to include a little more of that blood red in the rose that's affixed to the vampire's clothes, thus representing his thirst for blood. The application of color is very thick, with dots of paint close together, almost covering one another, and without much water mixed in. Even as thick as it is, because it's acrylic, the paint will dry in no time.

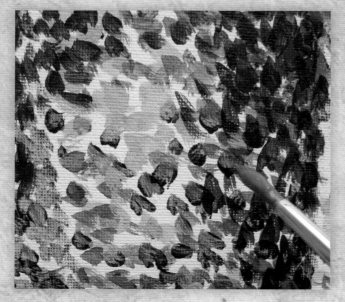

WARMING SHADOWS WITH RED

We're going to place red in the shadow areas, too. Light is warm and shadow is cold, so adding a warm red to the shadows may not seem like it makes sense, but on the edge of the shadows, we get a warm reflection from the light in the environment. So we're going to apply red to the very edge of the vampire's sleeve here.

We're also going to warm up the shadows at the edge of the vampire's top hat. We're creating more balance in the composition with this red, and we're also creating more dimension. But don't add too much! Note that there aren't a lot of red dots in the shadows, and there's a fair amount of space between them.

Feeding Habits

Do vampires have to prey on living people, or can they survive on animals, or even the blood supply stores of a blood bank? That all depends on who you ask. As humans, it's natural for us to want to see the good in people—and vampires. But sometimes that causes us to make up stories to excuse a behavior.

We explain away the evil "ick" factor by theorizing that, hey, they drink blood, but they don't kill the source—just borrow a little sustenance. Or we claim they drink human blood, but only when they're starving and haven't been able to find a rat or a cow on their hunt—they hurt humans only when they have to. Or we might even say that they drink blood, but try to stick to the donated kind rather than attacking living humans.

When it comes down to it, these explanations are just myriad excuses. Vampires need human blood—warm, oxygenated, protein-rich. They can't survive on animals, and chilled blood bags just aren't their cup of tea. We want to like vampires, but part of what makes them so appealing is their lawlessness. In other words, vampires are bad to the very core—let's accept them for who and what they are.

WHOLE
BLOOD

Affix
Donation
Number
Here

Expiry Date

For storage of whole blood.
Do not reuse if there is any visible sign of
deterioration. The fluid pathways of this
pack are sterile and non-pyrogenic.
Contents of unit pack must be used within 10 days
of opening.
Do not use after:

ABO and RhD
Group

Do not vent.
Do not reuse this container

Centre Identity

VOLUNTEER DONOR

Date Bled

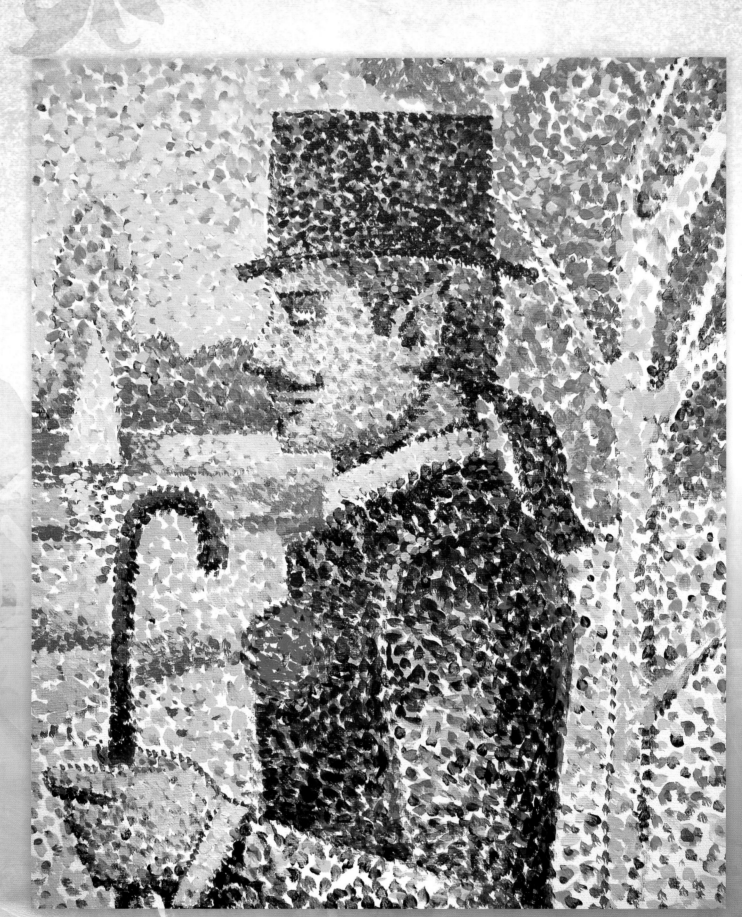

Step 8 In addition to red and orange, we're adding violet and, yet again, ultramarine blue, darkening the shadows and lightening the highlights. The vampire has pale skin, so we're going to dot blue and white over the red and orange to achieve that. The blue and white are more spaced out than the underpainted dots, resulting in a cold, almost transparent appearance. You can almost see the veins, a famous vampire feature.

APPLYING LIGHT COLORS

The color we apply to darken and lighten at this stage will help us give the impression of form, allowing us to define the roundness of the figure or the dimension of other objects. See the way the lightest colors are reserved for only certain portions of the hand (the top in particular)? This helps give the hand shape. The same applies to the head. Although there are many colors on the face, the lightest tones are reserved for the parts that require shaping, such as the cheekbones and the nose.

Although there are many colors on the face, the lightest tones are reserved for the parts that require shaping, such as the cheekbones and the nose.

There was a time when tales of vampires were considered much more credible. Although our modern society is fascinated by the night-walkers, the true believers now number few. So what does it take for a vampire to legitimately make the news in the modern day? An archaeological dig, apparently.

In March 2009, the Associated Press released a story from Rome, where a team digging near Venice unearthed a vampire.

Now, how did they know the skeleton they had dug up was a vampire slain in the past? The evidence of her slaying was still present. An ancient brick was lodged squarely between her jaws.

The vampire apparently died—one death, at least—during a plague, as she was buried in a mass grave with other victims of the 1576 epidemic.

Archaeologists suspect that those burying fresh corpses came across the woman. When reopening graves to add more bodies, they sometimes discovered older bodies that were bloated as if they'd just fed, with blood seeping from their mouths. More curiously, there would often be a hole in the shroud that had covered their face at the time of burial.

It was obvious to the grave diggers—as it would be obvious to vampire researchers today—that when they discovered such signs, they'd encountered a bloodsucker, or a "shroud eater" as they were then known. As one archaeologist explained: "they saw a fat, dead person, full of blood and with a hole in the shroud, so they would say: 'This guy is alive, he's drinking blood and eating his shroud.'"

Exorcism was accomplished through starvation: With a brick shoved into the vampire's mouth, she could no longer feed. A slower process than a stake through the heart, to be sure, but just as effective.

3-D SHADING

As we're getting nearer to the completion of the painting, the dots are becoming thicker, and the overlap makes them stand out more. This is helping add to the three-dimensional look and also producing a real physical texture to the canvas.

ENHANCING WITH WHITE

White is one of the last colors I apply. It really stands out against all the color of the background, "popping" even with all the other dots in its vicinity. You can use it to direct the eye to a particular area, like placing it on the collar to call attention to the vampire's face above.

HIGHLIGHTING WITH WHITE

Even though the boat's sail is "white," it reflects the blue colors of the sky and water. Its highlights, however, are thick dots of pure white.

White is one of the last colors I apply . . . use it to direct the eye to a particular area . . .

VARIATION IN CLOUDS

Taking a closer look at the clouds, they're not pure white masses either. The cloud has its own shadow (although a very light one) and it also has its own highlight color. The variation gives them dimension, so they don't just look pasted onto the sky.

Step 9 On to the final details: We need to work up the edges so some are blending into the background whereas others, like the silhouette of the body, are defined. We also need to develop background details—the bushes, a little boat, ripples on the water, leaves and shadows in the grass. And one final detail: moving the vampire's pupil toward the viewer, giving the portrait a more sinister look. That's all. Acrylic shines when dry, so varnish isn't necessary.

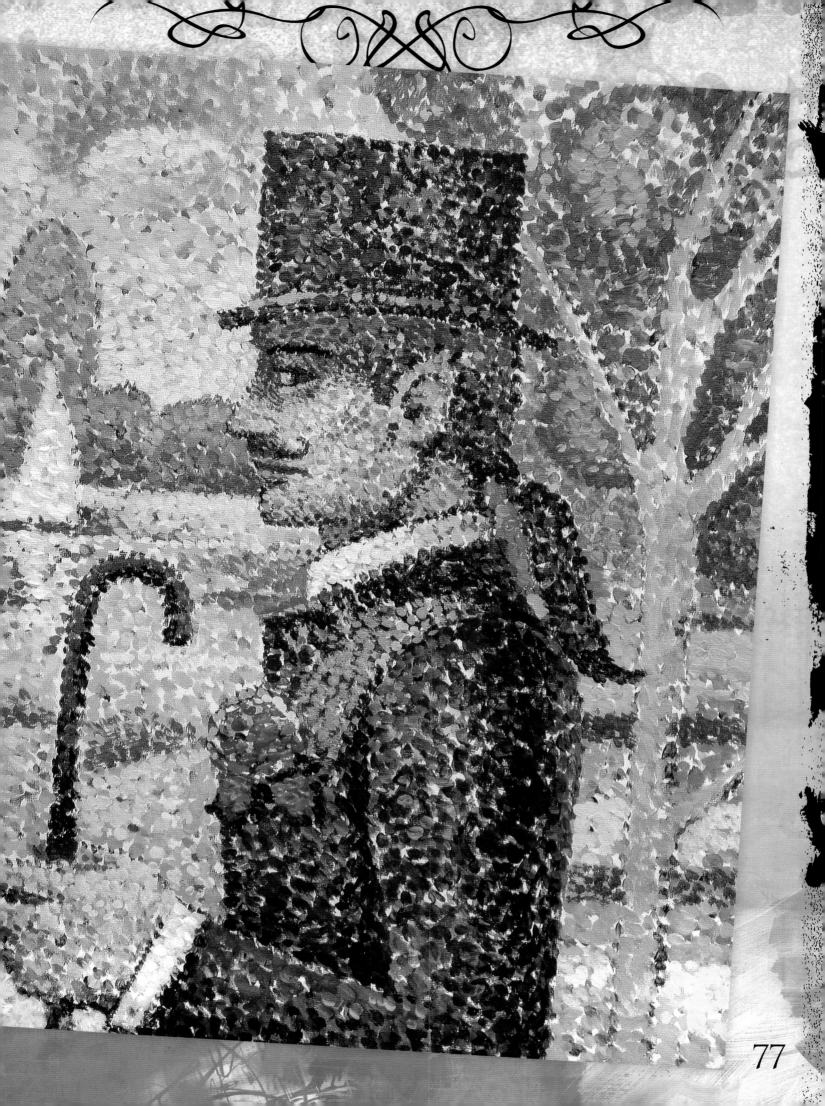

STUDYING VAN GOGH'S STYLE

Vincent van Gogh (1853–1890) was born in Groot-Zundert, The Netherlands. Little is known about van Gogh's earliest years, but his sister described him as a serious child, and we know he formed a lifetime bond and friendship with his younger brother. As the child of a minister, van Gogh enjoyed the privilege of attending boarding school, but he abandoned his studies at age fifteen, soon after joining a firm of art dealers.

Young van Gogh was successful in this line of work, and stayed on for a number of years. When he was transferred to London with the company, he was able to visit many art galleries and museums around the region, which would later influence his own art.

After seven years with the art dealers, van Gogh changed course and began teaching at a boys' school. He considered a transition from teacher to preacher, but found himself lacking when it came to both studies and service. After a brief stint as a clergyman in a mining village called Wasmes, he began his career as an artist, recording the hardships of the miners and the community through drawings.

Self Portrait with Felt Hat, 1887-88 (oil on canvas), Gogh, Vincent van (1853–90) / Van Gogh Museum, Amsterdam, The Netherlands / The Bridgeman Art Library International.

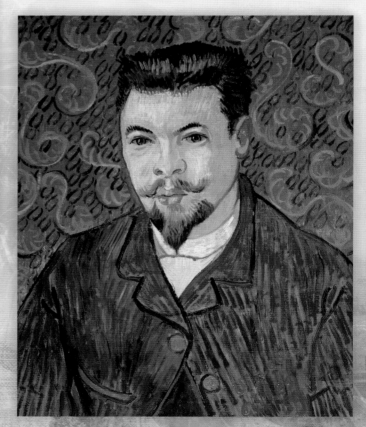

Portrait of Dr. Felix Rey, 1889 (oil on canvas), Gogh, Vincent van (1853–90) / Pushkin Museum, Moscow, Russia / The Bridgeman Art Library International.

He would continue his art education in Brussels, where he also began working with watercolor. He picked up oil not much later, and continued to refine his artistry after moving back into his parents' home in 1883. A sensitive, passionate man, van Gogh was most drawn toward emotional subjects, producing many portraits of laborers and peasants.

After his father's death, van Gogh moved to Paris, where the impressionists influenced his palette with their vibrant use of color. After two years, he grew restless and moved south to Arles, later followed by contemporary painter Paul Gauguin. It was during their time there that van Gogh famously severed his ear (although modern historians now believe that Gauguin in fact sliced it off in a quarrel over a lover).

Dr. Felix Rey oversaw the artist's recovery, but van Gogh's continually unpredictable behavior alarmed the citizens of Arles. In response to their concern, van Gogh checked himself into the Saint-Paul-de-Mausole asylum, where he would paint *Starry Night*.

Over the next year, van Gogh's mental health experienced ups and downs, but he had seemed to settle into a stable, established pattern before he committed suicide in 1890, shooting himself in the chest.

Van Gogh lived a passionate but stormy life. His breaking points are reflected in his painting style, with the interrupted brushstrokes, the frenetic energy, and the lines that dominate over the color. The restless, vigorous result is unlike any other master. And the emotion of the work makes it perfectly suited for a vampire subject. All his portraits have some similarities in style, but it's the look in the eyes and faces that suggest a person bordering on a psychological moment, about to break—or enter another state.

The Starry Night, June 1889 (oil on canvas), Gogh, Vincent van (1853–90) / Museum of Modern Art, New York, USA / The Bridgeman Art Library International.

PRELIMINARY SKETCHINGS

Van Gogh's paintings appear almost deceptively simply with their use of line and color—but don't be fooled by thinking we can simply put brush to paper to accomplish this style. We definitely need to do some preliminary sketching to be sure we capture the spirit of the vampire and the soul of the style.

PRELIMINARY SKETCH

Van Gogh's style is especially effective for rough characters and slightly unkempt types, so a haughty aristocratic vampire character won't make a good match for this master. Instead, after reviewing some of van Gogh's self portraits, I imagine a slightly sinister character who is a bit more worn down and roguish. It's this concept I very primitively sketch on paper to make sure my idea is a good one.

CHARCOAL DRAWING ON CANVAS

I think my general concept is a good one, so I'm going to flesh out the details, sketching with charcoal directly onto my 18" x 24" canvas. Start the sketch with the skull shape, which will determine the outline of the face. For the weary and the undead, the eyes should sit deep in the eye socket—despite that depth, there's a sharp intensity to the eyes, though. I want the vampire to be looking past the viewer, so I shift his gaze slightly, suggesting the vampire has spotted prey in the near distance.

BRUSHING OFF EXTRA CHARCOAL

The great thing about charcoal is you can rub out mistakes as you work, or wash out lines with a soft sponge. Once your drawing is set, though, you'll need to clean up the excess charcoal to make sure it doesn't muddy up the paint colors. Sweep the canvas lightly with a brush to make sure no loose residue is left behind.

DETAILING THE DRAWING

When you look at van Gogh's self portraits, you'll notice how the skull structure is really prominent; this type of exaggeration befits a vampire, too, so we're going to mimic that style here.

81

THE POWER OF SUGGESTION

As with Seurat's visually blended dots, van Gogh's interrupted strokes suggest shapes and movement, guiding the viewer's reaction to the artwork. We're going to take that power of suggestion one step further here with our subject, painting a very typical portrait that just happens to contain subliminal suggestions that the man could be a vampire; for example, blue lines in spots of the portrait will suggest vessels or veins visible through the skin, the widow's peak hairline will be just a bit more defined, the face will be strong and set atop a muscular neck, and the canines will be just a bit longer than makes the average person comfortable. We want the viewer to wonder if it is a vampire from a distance and to make subtle exaggerations to that effect.

THE PALETTE

To make this subject a departure from our previous studies, I've decided to make him a Scandinavian type—white with strawberry blond hair and a fair complexion. I want to use complementary colors here, as the master would himself, so if the hair is yellow or orange, the background should be violet or blue to make the figure really stand out. Pairings with such intensity are very characteristic of van Gogh. We'll be using oils, and painting a la prima, a one-session painting with thick, diluted strokes—so you'll need a larger palette but with just enough of each color for the portrait. In addition to my full range of color (yellows and earth tones transition into the cool greenish blues and the cooler colors at the opposite end of the palette), I have two separate large globs of titanium white, one a foundation for the earthy tones and one for the cool tones—I don't want those to mix.

MIXING A THINNER

Although we're going to be using oil, this painting is a one-session project, so our thick strokes still need to be diluted so they dry. The first applications will be thinner yet. So we'll definitely need a medium. I suggest you mix your own thinner with linseed oil, turpentine, and liquine, keeping it on hand in a metal container nearby while you paint.

Step 1 With the painting on a flat surface (so the thinned paint doesn't drip with gravity), we're going to start our painting with a bright, earthy color, a mix of cadmium yellow and red. Apply this with a medium brush in kind of a chaotic way, tracing the charcoal line around the face, neck, and clothes.

DYNAMIC MIXES

You don't want perfectly blended colors for this portrait—just loosely mix the fiery colors and then stroke with red, red-orange, and yellow. Keep adding more paint to the mix and to your brush as you go for dynamic, juicy, dimensional strokes.

Loosely mix the fiery colors and then stroke with red, red-orange, and yellow.

83

SHORT STROKES

Keep your strokes short, generally about 1"–2", although some will be longer. And the longer strokes tend to have more curl to them. You don't want lines that are too uniform in size, shape, or direction—van Gogh was a pretty impulsive and instable guy, so your strokes should resemble that attitude.

CURL AND MOTION

The curled strokes are giving a lot of movement to the painting, and they also direct the viewer's eye up toward the focal point, the vampire's visage. You'll rarely see completely straight or parallel lines in van Gogh's work—the curliness and the roundness add spirit to the painting.

SPONTANEOUS PAINTING

Keep moving quickly, without giving too much thought to the placement of your strokes. This should be a fast, spontaneous painting, not one that's overly labored and planned out. At this point, your brown and yellow and warm, earthy tones can go on any spot of your painting, just don't cover your outline.

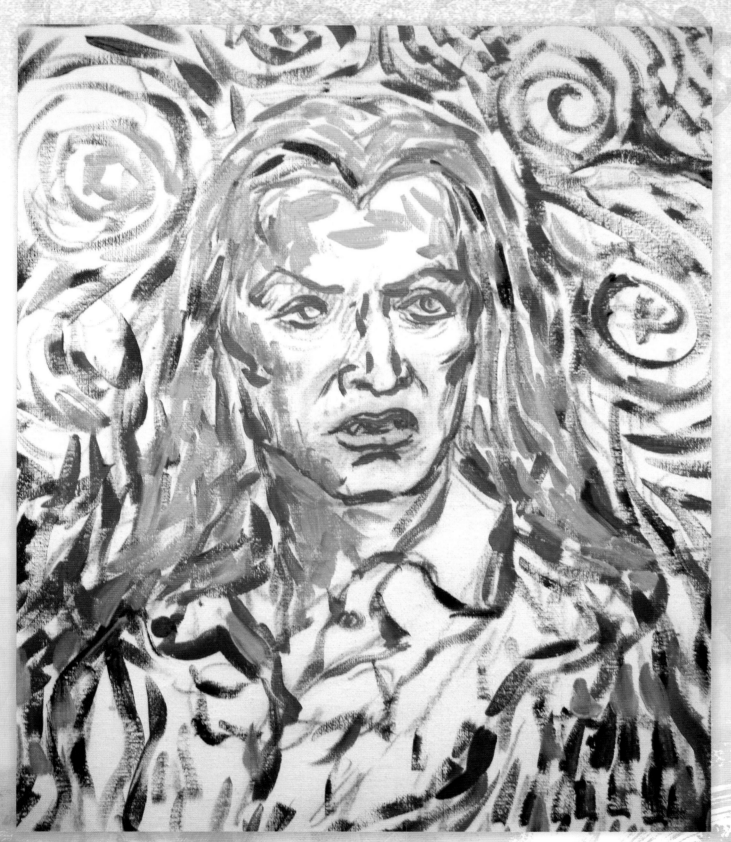

Step 2 At this stage, I'm working with a few different brushes, all of the same size. I picked up a new one for the yellow mixture so as not to interrupt the rhythm of my strokes by stopping to wipe off my brushes between colors. I'm using three shades of yellow—a bright cadmium, an orangey yellow, and Napoli. This will be a pretty dominant color for the painting; at this stage, I'm introducing it to the hair, the face, the neck, building the shapes with the brushstrokes. Later, we're going to add a lot more to those areas and also use the yellow for highlights.

INFUSING GREEN

The skin tone has a yellow base, but I'm going to add some green here for the more shadowed parts. Green mixed with Napoli yellow will produce a pale effect for the skin.

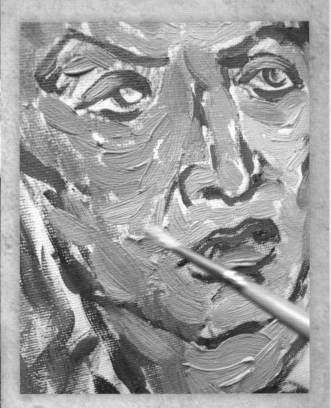

SHADING OPPOSITE THE LIGHT

The light source is coming from above and to the right of the vampire, so the shadows are on the lower left of his face. You'll still want to be able to see the red-orange outline.

BLOCKING SHADOW

Now we're going to start blocking elements of the face before we build more contrast. Establish a sense of shape and dimension with the application of a brownish-tinged yellow.

You'll still want to be able to see the red-orange outline.

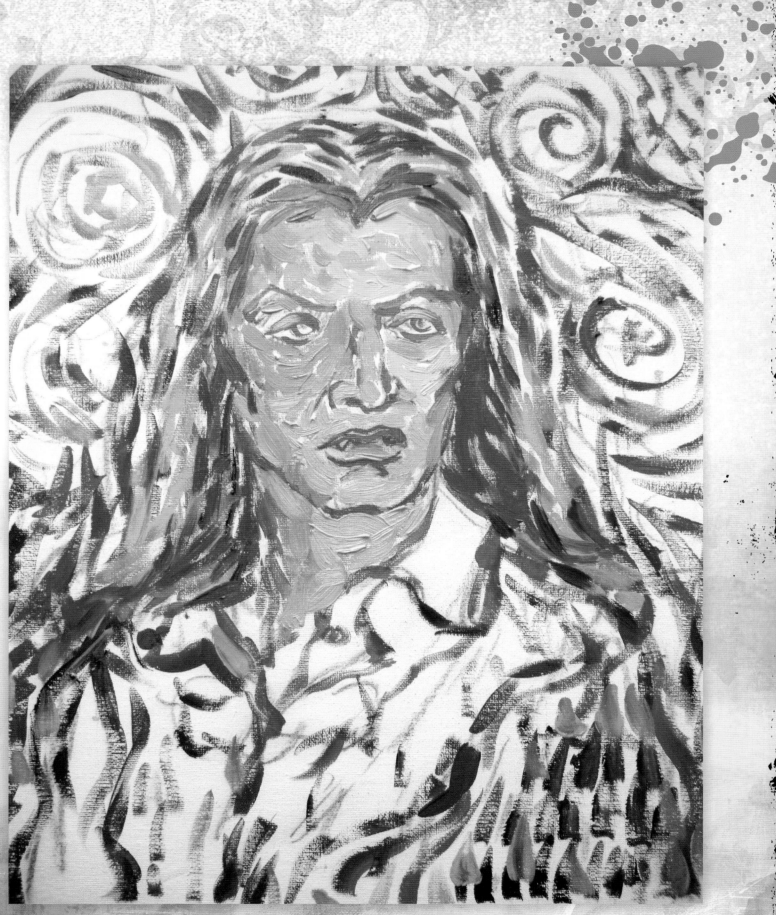

Step 3 In addition to the shadows of the face, we're overlaying the highlights of the hair with dark areas of brown. You can see two or three colors interlacing each other right on the canvas as the layers build up; it's a cool effect, and very typical of van Gogh.

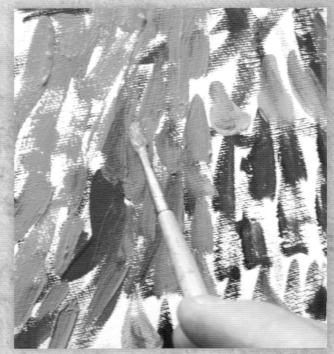

MIXING COOL COLORS

Now we're going to be working with some more blue and creating greenish-white strokes. Use the titanium white as the base, and work in some of the other colors, without over-blending. As you work, keep pulling in color for a lively look that isn't too uniform.

CONTRASTING CLOTHING

Typically, cool colors have a calming effect—but when they're applied in strong contrast, such as with this cool clothing offsetting the warm colors of the face—they're startling and unsettling. You can feed into that impression by making your brushstrokes as turbulent as the color contrast, applying quick, active strokes a hurried sense of motion.

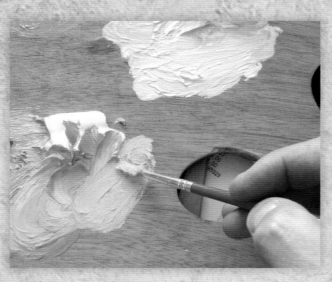

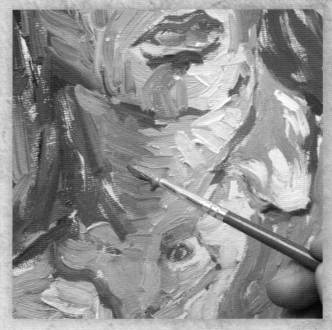

PREPARING HIGHLIGHTS

In step four, we're going to be focused on building up greater contrasts—part of that is building deeper shadows; the other part is establishing the lighter tones. Apply white mixtures that use generous amounts of white—and be sure to dab on strokes of the lighter colors everywhere on the canvas, so that the sky and clothes are radiant and reflecting on the face, the hair, everywhere. This is something van Gogh and the other expressionists always did, mixing everything together to create a sort of chaotic unity in their artworks.

DEVELOPING FORM

Although the strokes seem random because of the varying pressure and size of the strokes, the direction of the brushstrokes is very important for developing form. For example, the angle of the strokes along the neck help define its shape and provide dimension.

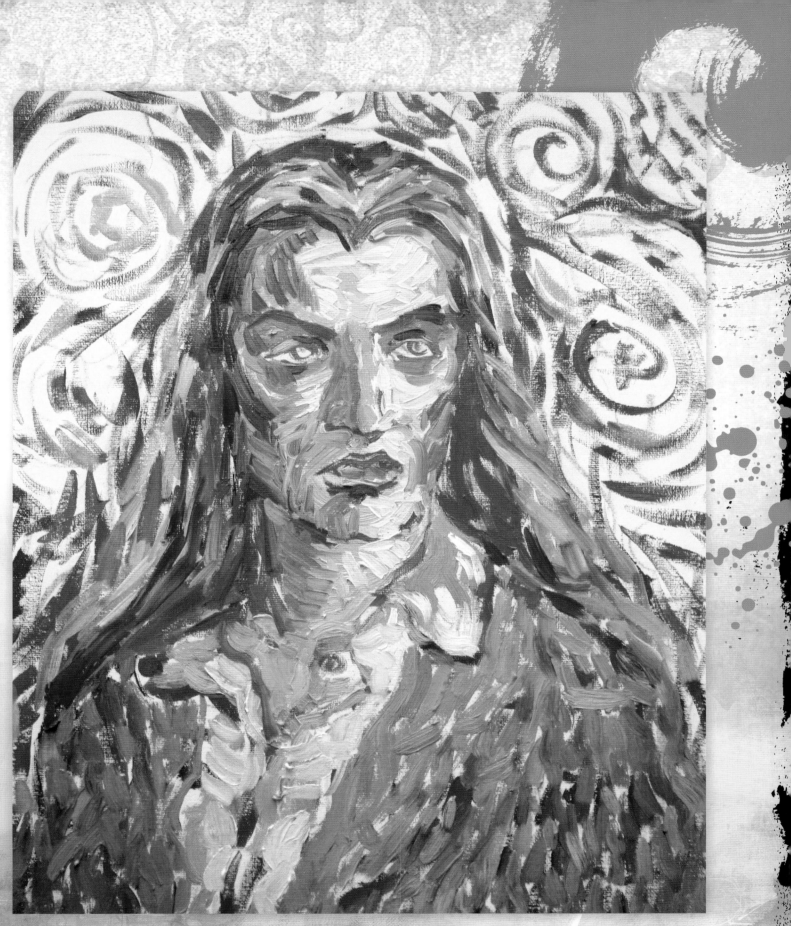

Step 4 As we're applying the light tones of the clothing and reflections, we're also heightening contrasts (and the tension and drama) by adding darker shadows to the face, as well as applying strokes of darker color within the hair. It's important to note that I haven't yet touched the eyes or lips, aside from the outlines—we won't fill them until closer to the end, because they are very essential to the imagery of this piece and require special attention. At this stage, our strokes are still bold and loose and wild; we'll adopt a different method when developing those more delicate features.

BACKGROUND SWIRLS

Van Gogh's swirls are instantly recognizable, so we're going to add the master's signature style to our portrait, as well. The multiple, swift lines that make up the curly, swirled strokes add movement and texture to the painting, and they also create a sort of restless energy that vibrates throughout the artwork.

BUILDING UP COLOR

The swirling lines are a combination of violet and cobalt blue, mixed together and separately with a lot of white. These base colors are very light, but we'll be building on these as the painting progresses. Working light to dark is the opposite of most oil painting techniques, but it will produce some very vibrant results for us, as it did for van Gogh.

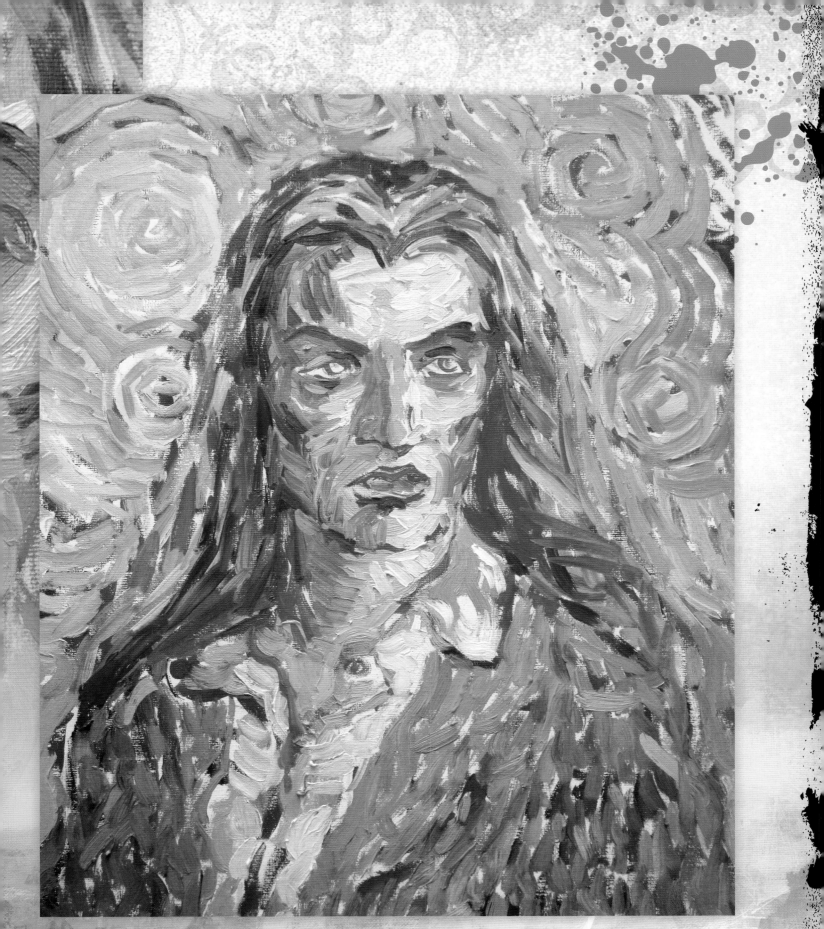

Step 5 Keep applying the interrupted dashes of swirls, covering the entire background of the canvas. Right now, all the elements of the painting are still somewhat distinct, leading their own existence, and you can still see the original outline of the figure pretty well. Now that we have all our short and curly strokes of texture built up, though, we can work on unifying the piece and better defining the detail of our vampire.

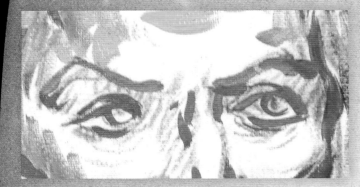

OUTLINE

We started developing the vampire's eyes with a simple red outline—fitting that our creature of the night would have bloodshot rims, no?

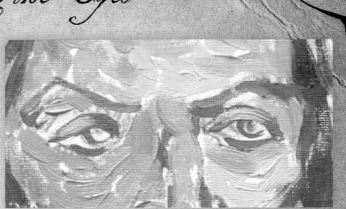

SKIN

But we haven't developed the eyes much aside from their initial shape, adding a stroke of skin color above each to define the fold.

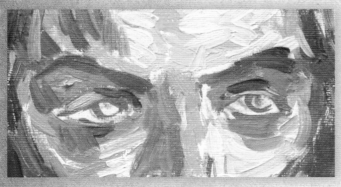

SHADOWS

We gave them depth with carefully placed shadows, making the sockets seem set back and a little hollow with little effort.

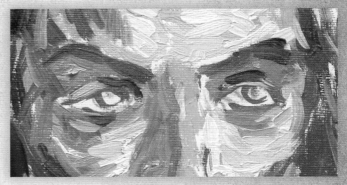

DEPTH

Highlights of violet and green set the eyes back even farther in the skull, aging our vampire and giving him a haunted expression.

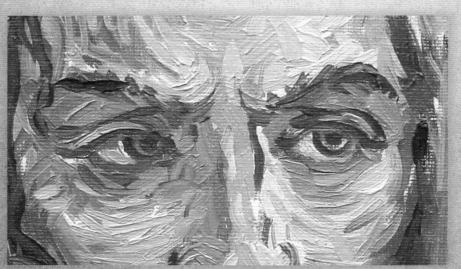

DETAIL

Now we're ready to apply color to the eyes themselves, not just the skin surrounding them. Applying crimson-red irises, blood-rimmed pupils, and fiery lashes brings life to these undead eyes—and a cold chill to the viewer.

Step 6 With my smaller brushes in hand, I'm adding detail, including facial hair that gives our subject a certain rough masculinity. (Van Gogh was a fan of the effect of an unshaven subject himself.) I've added more dark strokes to define the figure's silhouette, and I've added detail to the eyes. I've also filled the bottom lip, using a cool color that is reflective of the moon. As I work, I'm also continually "correcting" the drawing, further defining lines and making the drawing better and better. Since the oil has still not hardened, it's easy to fix things in subsequent layers. Don't be afraid of adjusting your own work.

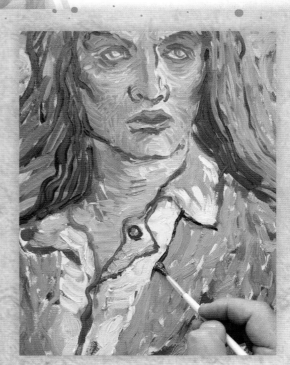

DEFINING THE OUTLINE

I've switched to a slightly smaller brush for the more refined work that's ahead. I've mixed cobalt blue and burnt umber to create a lively dark mixture for outlining. Van Gogh didn't really pay attention to the accuracy of his drawings at the beginning, and he used these fine "black" lines as a way to correct his original line drawings, after they had been adjusted throughout the painting process. The dark outline has a way of putting things in their right place; even if the colors are running together, the dark line over top somehow organizes the elements of the silhouette below.

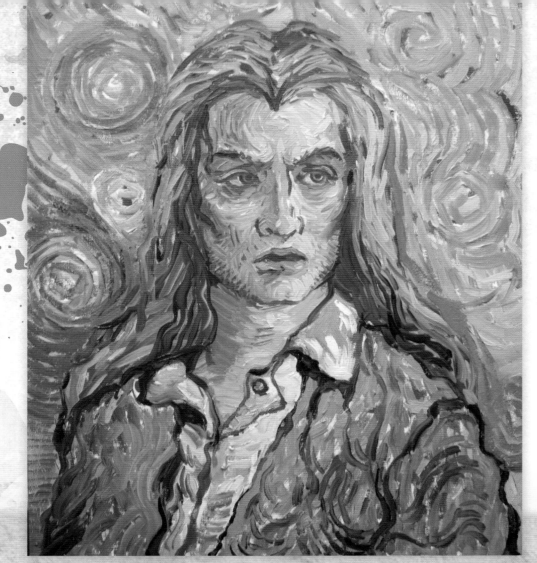

Step 7 We've reached a stage where the major work is done, and what's left is adjusting the contrasts and refining the darker lines. By this time, you already see the major contrasts between the sections of shadow and light. This is our final chance to adjust brushstrokes and details, but we don't want to overdo this. Things don't have to precise; they don't have to be perfect. Let the viewer's mind complete the painting. Let them think. Leave them room to think. The beauty of the expressionist style is that elements lead their own life on the canvas—not unlike vampires, a long life where there is no end.

CONTRAST AND COMPLEMENT

To darken the background, I am retracing over the same strokes, repeating them, but this time with a darker and purer blue color. The additional layer of color will give me more contrast, and it also will complement the golden colors, charging the painting with more energy.

FINISHING TOUCH

Although it's true we want to leave our artwork slightly unfinished, there's one detail we don't want to miss: two subtly elongated canines. That's a signature element for the vampire, and it will complete our portrait.

Step 8 After touching in the final details—including two dark pupils that complete the vampire's hauntingly hollow gaze—my painting is complete. Some interesting things occurred here that I didn't expect—for example, the bright, light shirt, or the slight lean of his pose. But these are happy accidents, and they work in favor of the portrait, creating interest and movement. Sometimes it's good to relax, and not be totally in control of the situation—unless, of course, there's a vampire lurking.

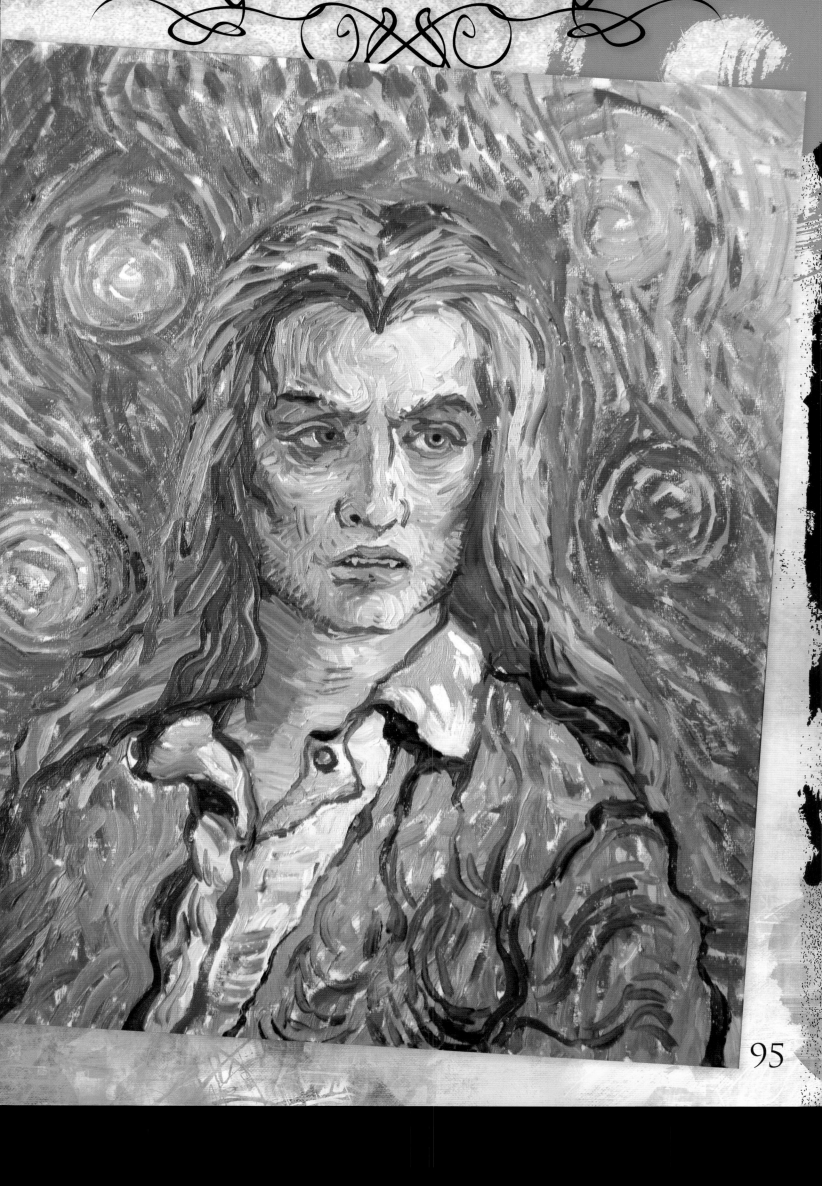

Oath of the Masters

I, _____, understand that I have been entrusted with a collection of rare and precious manuscripts. I commit to learning the great masters' artistic secrets within these hallowed pages by drawing daily and earnestly practicing the masters' techniques and styles.

I, _____, further understand that the information regarding vampires I now possess comes with great responsibility. I commit to using this knowledge for the sole purpose of advancing the study of vampires and vampire portraiture.

I, _____, agree to scrupulously guard these manuscripts against those who might use the contents to obtain fame or fortune.

Signature

Date